IMAGES
of Aviation

MIDWAY AIRPORT

IMAGES
of Aviation

MIDWAY AIRPORT

David E. Kent

ARCADIA
PUBLISHING

Published by Arcadia Publishing
Charleston, South Carolina

Printed in the United States of America

Library of Congress Control Number: 2012945461

For all general information, please contact Arcadia Publishing:
Telephone 843-853-2070
Fax 843-853-0044
E-mail sales@arcadiapublishing.com
For customer service and orders:
Toll-Free 1-888-313-2665

Visit us on the Internet at www.arcadiapublishing.com

*To all who still look up at the sound of radial engines and
know, remember, or yearn for the thrill of flying*

CONTENTS

ACKNOWLEDGMENTS

This author is deeply grateful to all the Midway Historians for their expertise, eyewitness accounts, historical information, photographs, stories, facts, and data connected to Midway Airport. Their contributions reflect an unparalleled depth of knowledge and dedication to the preservation of Chicago aviation history. Among them are Michael Branigan; Edward Cermak; John Chuckman; Wallace D. "Dip" Davis; Capt. Walter Dorn; Charles Feigel; Gerald R. Hecko; Robert M. "Moose" Hill; the Howard Aircraft Foundation; Robert Jesko; Martin E. "Marty" Johnson; Willis D. "Chic" Johnson, the LaGrange Historical Society; Sheila O'Carroll Lynch; Jeannine McLaughlin; Elmer H. Maves; Ruth Osgood; Capt. Rex Painter; William Poturica; Laird A. Scott; Nicholas Selig; Robert F. Soraparu; Ronald Stuart; Dan Uscian; Capt. Phil Walpole; Lawrence "Larry" Wangerow; Thomas E. Wartell; the Western Springs Historical Society; David M. Young; and Arnold A. Zimmerman.

The author is indebted to those who helped shape this work and assisted with peer review, editing and fact checking. M. Christopher Lynch, the author's "Midway brother," was always near as a mentor and guide. Capt. Robert "Bob" Russo and Patrick Bukiri remained virtually by the author's side to advise, elucidate, and offer comment. Bob answered every question asked about Midway and added exciting historical facts as well. Pat was always available with research on photographs and time lines. Jon Proctor, John "Jack" Dusak, Robert "Bob" Dusak, William C. "Bill" Aitken, and Capt. Charles "Bud" Cushing carry a wealth of TWA history. Each one checked facts and made critical contributions and edits. John Devona and Capt. Elroy "Buck" Hilbert contributed amazing stories from the perspective of United Airlines. Robert F. "Bob" Zilinsky gave light to this work with his nearly nine decades of aviation history, including his flying career with American Airlines. William "Bill" Ritchie provided exhaustive documentation, studies, and history from the 1940s and stories about Chicago during World War II. The author is extremely grateful to senior production editor Mike Litchfield of Arcadia for his tireless dedication and expertise in taking this book from manuscript to finished work.

Many more on this dedicated team directly molded and shaped this story of Midway Airport. Each has invested greatly in the airport's enduring legacy. And some have "flown West" since this project began; although they are sorely missed, they live on in these pages and in history.

Finally, the undersigned wishes to express his deepest gratitude to his wife, Nancy, for her encouragement, support, prayers, and devotion. She still laughs at how, on their first date, he drove them to Midway Airport to park—to watch the airplanes!

Every member of this team is the author's great friend. His hope is that each one will celebrate his or her accomplishment on these pages. Their contagious enthusiasm and splendid contributions made this book a reality, and they have truly done excellent work.

—David E. Kent

INTRODUCTION

Those who yearn to fly, who have ever dreamed of being involved in aviation, understand its allure and mystique. The first Chicagoan integral to aviation's advancement from dream to reality, Octave Chanute, certainly did. Chanute was an aviation visionary who studied the designs and experiments of German glider pioneer Otto Lilienthal, who had said, "To design a flying machine is nothing. To build one is something. But to fly is everything." Chanute did not live long enough to experience the thrill of flight, but his work was not lost on Orville and Wilbur Wright, who borrowed directly from his knowledge and glider designs. And on December 17, 1903, the Wrights and their engine designer, Charles Taylor, made aviation history.

Chicago had been a center of ballooning since 1848. In 1905, an airship facility was built at the White City amusement park, the original site of the 1893 Columbian Exposition, or World's Fair. After the Wrights' 1903 flight, Chicago was even more eager to welcome the aeroplane, yet the first flier to visit Chicago would be Glenn Curtiss in 1909. An ambitious motorcycle builder and racer from Hammondsport, New York, Curtiss was the first of many aviation greats to come to Chicago. Others included Chance Vought, Glenn L. Martin, Matty Laird, Benny Howard, and Katherine Stinson, to name a few. Curtiss set up shop on Clearing Field, at Sixty-fifth Street and Major Avenue, and continued to improve upon the Wrights' accomplishments. Additionally, although Curtiss proved a more energetic promoter than the Wrights, both parties soon competed in the city in air exhibitions and races with big prizes.

Flying became big business nationwide long before airlines came on the scene, and well-known fliers descended upon Chicago for the prizes. In 1911, Grant Park was designated as the site of the first Chicago air show featuring heavier-than-air craft. The crowds loved it. Britain's T.O.M. Sopwith was there and won $14,000. Lincoln Beachey, flying a Wright Flyer, won $11,000. In those early years, successful Chicago businessmen Charles "Pop" Dickinson and Harold F. McCormick organized the Aero Club of Chicago, the basis for flying in the city. Dickinson purchased 640 acres for a new airport at Eighty-third Street and Cicero Avenue, which he named Ashburn Field, and moved the club's headquarters there from nearby Cicero Field. Octave Chanute, who had died during his first term as the Aero Club's first president, received the posthumous honor of having one of Illinois's two new military air bases named after him as America joined World War I in 1917. By that time, Chicago had contracted a hopeless case of flying fever.

In 1918, an explosion in postwar aviation activity occurred. The federal government had just organized the Air Mail Service and needed a Western terminus for new transcontinental airmail routes. Contracts were awarded to airlines, and Grant Park and Ashburn were initially considered as possible airmail depots. Ashburn was the largest and best airport in Illinois, but it was marshy, and the runways were unable to physically support the heavy biplanes being used to fly the mail. The Post Office Department was compelled to settle on Grant Park, but it continued to eye other possibilities for a new, all-weather municipal airport. Meanwhile, a small airfield opened in suburban Maywood, purchased by a men's clothier and operated by Lt. David L. Behncke, an alumnus of Chanute Air Base in Rantoul. This small airport became known as Checkerboard Field.

Then, disaster: on July 21, 1919, while on a sightseeing flight from Grant Park to its base at White City, the new Goodyear airship *Wingfoot Air Express* caught fire over the Loop, crashing through the massive skylight of the Illinois Trust and Savings Bank. Fire from the plummeting wreck ignited the fuel, resulting in a conflagration within the bank below. The crash killed three airship passengers and 10 bank employees and injured 28 more inside the bank. Many in Chicago reacted by declaring aviation patently unsafe.

In 1920, the Post Office Department transferred airmail operations from Grant Park to Checkerboard. However, in 1921, due to lack of sufficient government funding following the cancellation of some airmail routes and recent hangar fires at Checkerboard, the department moved its airmail operations across First Avenue to government-owned land. The new airport, christened Maywood Field, remained the western airmail terminus until 1927.

In October 1922, the Aero Club's Pop Dickinson convinced Chicago mayor William Hale "Big Bill" Thompson that additional airports were needed to promote flying and augment Ashburn's viability. Subsequently, the mayor had a small flying field built southwest of Chicago on a quarter-mile tract of land off Fifty-ninth Street and Cicero Avenue. It had one hangar and two dirt landing strips. Col. Philip G. Kemp headed up operations there, which consisted mainly of flights originating at Ashburn and Maywood. That bucolic little airfield would soon change aviation history and the world.

One

BIRTHPLACE OF MODERN CIVIL AVIATION

The unique little airfield was on an open square mile of land owned by the Chicago Board of Education. It consisted mainly of truck farms, a golf course, and a railroad track bisecting the mile at Fifty-ninth Street. There was even a tavern, Al Marshall's, at Sixty-third Street and Cicero Avenue. It was known into the 1930s as Buckmeier's Tavern.

By 1923, Colonel Kemp's flying field had at least one tenant, the Chicago Air Park Company, which offered flying lessons and aerial photography. Still, the field remained all but deserted. Then, in February 1925, Pres. Calvin Coolidge signed the Kelly Act, turning airmail transportation from the post office over to private carriers by authorizing the granting of airmail contracts on a low-bid basis.

Meanwhile, the Chicago Planning Commission continued to discuss a modern, all-weather municipal airport. No action followed, however, until aircraft designer and builder Emil Matthew "Matty" Laird approached the commission in March 1925 with a request to lease the airport at Sixty-third and Cicero for his airplane factory. The productivity of his operation on Ashburn Field was severely hampered by the airfield's primitive conditions. Laird's request motivated the commission to negotiate with the board of education to permanently lease the site for the new airport. Colonel Kemp reached an agreement for a 25-year lease on 300 acres of the land for the new airport, and funding was secured for airfield improvements. Pop Dickinson, realizing his mission was over, sold all but 80 of Ashburn's 640 acres. Laird's request to relocate his factory to the new field was, ironically, rejected; he subsequently built his new facility on Eighty-third Street, at Ashburn's northern edge.

Airmail routes formed the basis for the first airlines, all of which began as air mail carriers flying World War I–era aircraft. Systems were established to accommodate all-weather airports and en-route facilities essential to flying a Chicago–San Francisco night route. Installation of illuminated signal beacons every 25 miles between Chicago and Cheyenne, Wyoming, began in 1923, and land was also rented for emergency airstrips at specific locations along the route. Airmail routes were added, and successful testing proved the viability of the new systems. In 1925, the first five airmail routes were awarded to a new Chicago airline, National Air Transport (NAT). In February 1926, another new airline, begun by William Stout and owned by the Ford Motor Company, was the first to actually fly the mail.

On Saturday, May 8, 1926, the new municipal airport opened in a partially completed state to great celebration. The first aircraft to land there was one of NAT's Curtiss Carrier Pigeon biplanes, flown in from Maywood by Edmund Marucha and christened *Miss Chicago* for the ceremony. The Chicago Commerce Association decreed that the airport would have an important effect on air commerce. NAT would later become part of United Airlines, which grew quickly with the new airport. That same year, the new Nathan Hale Elementary School opened on the west side of the square mile, near the corner of Sixty-third Street and Central Avenue. After all, this was "Board of Ed" land, and the new airfield was quiet.

In August 1927, Charles A. Lindbergh landed at Municipal on a whirlwind tour of the country following his epic New York–Paris flight, drawing hordes of admirers. On December 1, all airmail operations shifted from Maywood to Municipal after hangars and new cinder runways were completed. The first airmail flight arrived from Omaha, Nebraska, piloted by Capt. Ira O. Biffle, the man who had taught Lindbergh how to fly. Biffle had just flown an open-cockpit aircraft 470 miles in December. The airport was officially dedicated on Monday, December 12, by Chicago mayor William Hale Thompson. Within its first full year of operation, "Muni" flew airmail; but out of 41,660 flights, the airlines also flew 15,498 passengers.

Chicagoan William B. Stout, who had partnered with Ford Motor Company, moved to Detroit to design automobiles after designing the popular Ford Tri-Motor, the first US-designed all-metal passenger transport.

Anthony Fokker, a Dutch World War I fighter plane designer, paid a visit to Muni in 1928 in one of his new F.10 trimotors. Soon afterwards, passengers began traveling with the airmail. Other airliners began gracing Muni's ramps as well: the Laird Commercial, the Boeing 80A, the Curtiss Condor, and later, a variety of Stinson "gullwing" Reliants, plus the larger Stinson SM-6000s. Whereas the Fords were all metal, Boeings, Curtisses, Fokkers, and Stinsons were primarily constructed of wood or steel tubing with fabric covering. In the early 1930s, these represented the most advanced commercial aircraft flying at Chicago Municipal.

Among the other fliers came a young Chicago barnstormer, Pierce "Scotty" O'Carroll. He had learned to fly in a Curtiss JN-4D Jenny at Ashburn. Ashburn fliers had been using Chicago Air Park as a stopping-off place since 1923, and a logbook entry dated August 1928 shows the first of O'Carroll's numerous puddle-hops to Muni, flown in a Travel Air OX-5 2000. The young Irishman was destined to become as much a fixture at this new field as the airline pioneers.

Another young "resident" of Municipal as early as the 1920s was not a pilot at all. Nonetheless, Mike Rotunno promoted both the airlines and the people who flew them with unstoppable energy and panache. Originally from Taylor Street, Rotunno was an original Chicago paparazzo, and in 1928, he captured a young aviatrix named Amelia Earhart on film during her stop at Muni.

In 1929, Lt. James H. Doolittle became the first aviator to take off, fly, and land solely by reference to flight instruments: all-weather instrument flying was now a reality. That accomplishment did more to insure flight safety than any other technological leap in aviation since the invention of the parachute. It also increased the utility and frequency of flight operations. Flights had become so numerous at Muni that a flagman was routinely used to sequence and direct aircraft taking off. The earliest form of air traffic control, flagmen remained until two-way voice communications between pilots and controllers began at Muni in 1933.

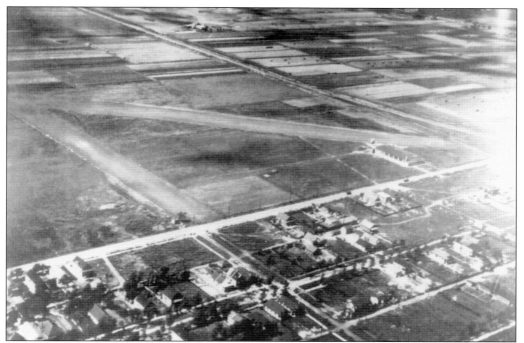

The Midway Airport of today began with Chicago Air Park, seen here, in 1923. Even after modernization and a formal dedication on May 8, 1926, there was little activity at Municipal Airport until December 1927. (Courtesy of Chicago Aerial Survey.)

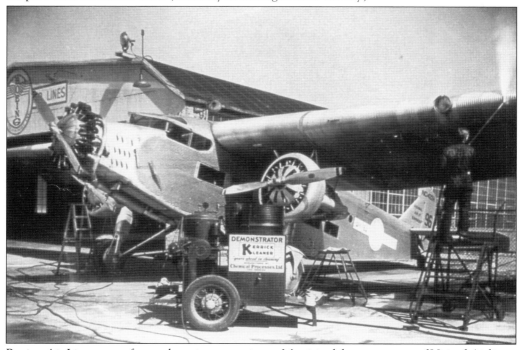

Boeing Air Lines, one of several carriers operating at Municipal, became a part of United Airlines. This early-1930s photograph shows a Ford Tri-Motor in front of the Cicero Avenue hangar complex. (Courtesy of Robert F. Soraparu.)

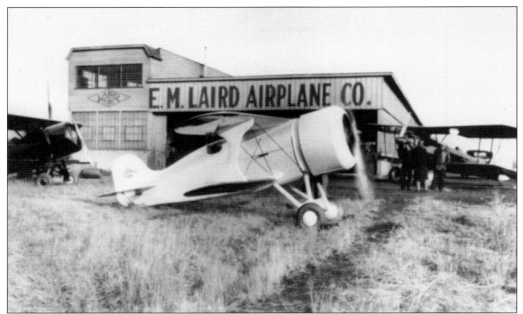

"Matty" Laird, the air-racing luminary, sought to move his factory from primitive Ashburn Field, at Eighty-third Street and Cicero Avenue, to the new Municipal but was turned down by the city planners. This shop was his second at Ashburn, located on its northern boundary. (Courtesy of Patrick Bukiri.)

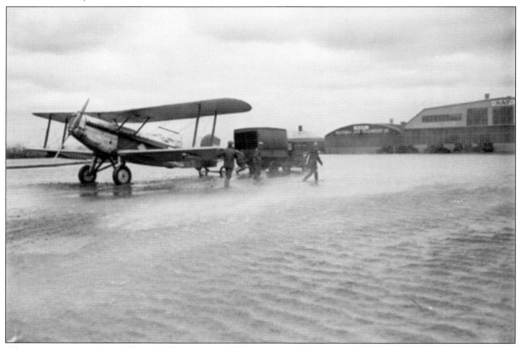

Chicago meteorologist Tom Skilling wrote, "The wettest Easter occurred in 1929 when 3.12 inches of rain soaked the city, forcing the cancellation of the Easter parade and flooding underpasses and viaducts—and Chicago's fledgling Municipal Airport, now Midway." This photograph shows the airmail going out despite the deluge at Muni. (Courtesy of Robert F. Soraparu.)

The first electronic navigation facility in Chicago was this four-course, low-frequency-radio range station, commissioned in 1929 and located at Fifty-fifth Street near Central Avenue. "Chicago Radio" provided state-of-the art navigation for pilots flying into the field in instrument weather through the 1940s. (Courtesy of David Young.)

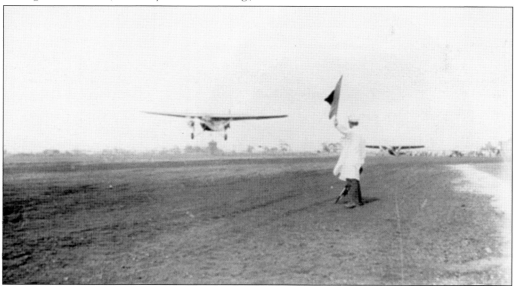

In 1929, airline employees in crow's nests often radioed pilots with directions for landing in fog. In visual conditions, flagmen were used; in this photograph, a Ford Tri-Motor is cleared for takeoff. (Courtesy of Robert F. Soraparu.)

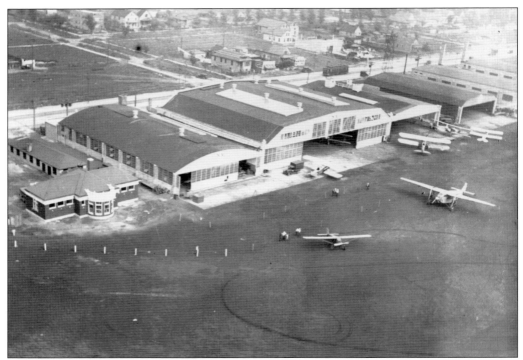

This 1929 photograph shows the first Muni terminal at the far left, flanked by the United Airlines hangars. Col. Philip G. Kemp's original Chicago Air Park hangar is the first hangar on the left. (Courtesy of Patrick Bukiri.)

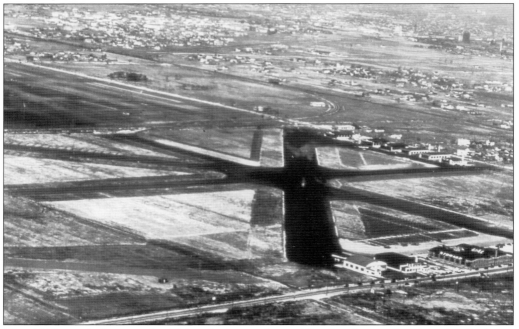

This 1929 aerial photograph of Muni looks northeast. The four hangar buildings in the lower portion of the photograph are, from left to right, Air Associates, Gray Goose Airlines, and the double hangar of Universal Airlines. (Courtesy of Chicago Aerial Survey.)

Two

THE WORLD'S

BUSIEST AIRPORT

By 1930, Chicago was the hub for one-fourth of US airmail routes, and the airlines were maturing into large companies. In 1927, William Boeing and Pratt & Whitney's Frederick Rentschler, who supplied Boeing's engines, formed United Aircraft and Transport Company, which included Boeing Air Transport (BAT) as well as smaller airlines and small aviation manufacturers. Rentschler also eyed successful National Air Transport (NAT), as did rival financier C.M. Keys, who desired coast-to-coast passenger service for his Transcontinental Air Transport (TAT), later TWA. Shareholder battles between Rentschler and Keys resulted in a Rentschler victory. The result was United Aircraft and Transport, the nation's first transcontinental airline, which later became United Airlines (UAL). In 1930, Boeing Air Transport became the first airline to utilize female cabin attendants with the hiring of Ellen Church, a registered nurse. Being a nurse was once a prerequisite for the new stewardess position.

Concurrently, three other dominating airlines came onto the scene: Eastern Air Transport, Transcontinental and Western Air (TWA), and American Airways, all consolidations of smaller carriers. These airlines were legacy carriers and became the "Big Four."

The first of many airport incidents at Muni occurred on the night of June 25, 1930. Two of several large hangars on the south ramp (Sixty-third Street) belonged to Universal Airlines and Stout Airlines. The latter had leased its hangar to Jonathan E. Caldwell to house and service aircraft for his exclusive luxury carrier, Gray Goose Airlines. Just 50 feet to the east, in the Universal Airlines hangar, several pilots and mechanics were preparing aircraft for airmail-flying the following morning. Somehow, a spark occurred at the rear of Universal's hangar, which resulted in an explosion, immediately erupting into an intense fire. The personnel evacuated, but only five aircraft were saved. The enormous fire spread flaming debris to the Gray Goose terminal 50 feet away, engulfing it in flames. A total of 27 aircraft, including 12 Ford Tri-Motors, were destroyed, and the airport was plunged into darkness when the power lines along Sixty-third Street were burned away. Emergency lighting had to be hastily procured to illuminate runway boundaries so that pilots stranded above could finally land, averting crashes and fatalities. Both buildings were completely destroyed, and the total damage was estimated at more than $2 million, well in excess of the entire square mile's 1926 land valuation.

In late 1931, a second passenger terminal opened, at Sixty-second Street and Cicero Avenue. Also, although aviation was thrilling, there were crises. An event that tried the public's confidence had occurred eight months earlier, on March 31, when the wing of a TWA Fokker F.10 trimotor buckled in flight over Bazaar, Kansas, crashing and killing eight people, including famous Notre Dame football coach Knute Rockne. The public recoiled in fear and horror, seeing flying as dangerous. Despite the national pall, Muni experienced an increase in passengers and operations in 1931, even in the midst of the Great Depression.

In 1932, presidential hopeful Franklin Delano Roosevelt made a goodwill trip by air with his family to Chicago from Albany, New York, in a Ford Tri-Motor. Before accepting his party's nomination for president at the Democratic National Convention, Roosevelt was greeted at the airport by thousands. He energetically reassured the throngs and the rest of the nation that if flying were not safe, he and his family would not be doing it. The public bought it; FDR had embraced and promoted flying at Chicago's airport, recognized for the first time as the "World's Busiest Airport." In 1931, a total of 100,847 passengers flew on 60,947 flight operations at Muni.

The airlines also reassured the public that air travel was safe and getting safer. The year 1933 saw the first Curtiss T-32 Condors, flown by American and Eastern. The giant twin-engine biplanes sported luxury appointments and a 170-mile-per-hour cruise. And they sang: it was said that as the Condor approached on short final in its low-throated, power-off configuration, people at the terminal could hear the flying wires sing and thrum as the airplane touched down. Thousands of visitors flocked to Chicago's airport to experience these wonders, especially on summer afternoons and evenings. They found these giant airplanes mysterious, loud, amazing, and quite beautiful. In short, Chicagoans could not get aviation, or this place, out of their blood.

In 1934, Boeing introduced the 247, the safest, most advanced airliner ever. At first, the sleek, low-wing aluminum twin was produced exclusively for use by United. This imposed restriction had a galvanizing effect on the other airlines that would make aviation history.

Although advanced, fast, and lightweight, the Boeing 247 seated only 10 passengers. Additionally, the wing spar carry-through structure extended into the passenger cabin, making passage down the aisle difficult. "Surely, we could do better than this," mused the airline have-nots: enter the airplane that would change the world.

In 1931, Orville Wright, awed by Municipal, wrote, "With the opening of 'Chicago's new front door,' the Chicago Municipal Airport, the world became smaller. St. Louis, Minneapolis, Detroit and Cleveland became suburbs. To one viewing the scene for the first time there is a thrill to see the nonchalance, the matter-of-fact way." Wright also penned with incredulity how the airport and people "lend a glamour to the whole scene. What a remarkable age we are living in," he concluded. Many wrote that "the Air Age was upon us."

However, it seemed that only airline pilots, racers, and the wealthy were flying in those years. One Chicago aviator, Pierce "Scotty" O'Carroll, believed that anyone, regardless of economics or class, should by able to fly. O'Carroll likely did more to fulfill the dream of flight for every man than anyone since Chanute or Dickinson. In the 1930s, O'Carroll became Municipal's fixed base operator (FBO), Monarch Air Service, on the east ramp. From his Cicero Avenue hangar, O'Carroll and his crew fueled and repaired visiting aircraft, performed maintenance, offered rides and air charters, and watched Muni grow. At Monarch, anyone could buy a ride for $3.50 and experience the thrill of a 20-minute flight over Chicago, enjoying air travel as only the pilots or the rich otherwise might. Throughout his career, O'Carroll owned the most modern aircraft of the time: a Fleet trainer, a Travelair E-4000, a Stinson SR-10 Reliant, a Beechcraft Staggerwing, a Stinson SM-6000B trimotor, a Douglas DC-3, a Curtiss C-46 Commando, and two Ryan Navions.

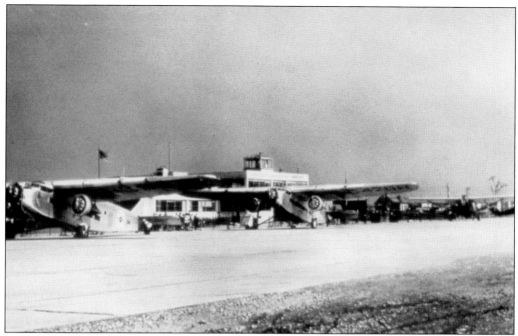

Muni's second terminal opened in 1931 at Sixty-second Street and Cicero Avenue. It became a visitors' mecca immediately, requiring police to cordon off crowds from the ramp. In this 1931 photograph, two Ford 4-AT Tri-Motors and another aircraft, possibly a Pilgrim or Fokker, queue up. (Courtesy of Robert F. Zilinsky.)

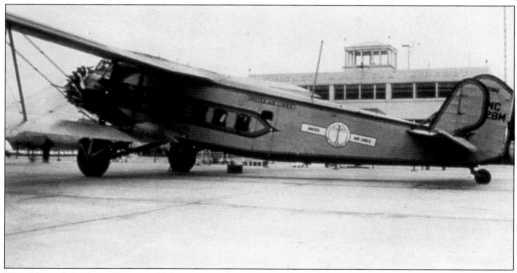

The United Airlines Boeing 80A was an often-seen early airliner at Muni. However, it was quickly replaced by the Boeing 247, which introduced all-metal construction in aircraft. (Courtesy of Patrick Bukiri.)

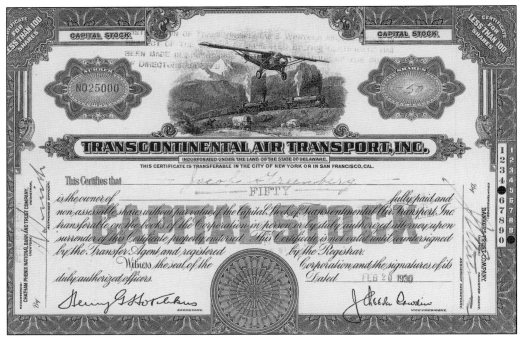

As the "Big Four" airlines grew in the early 1930s, the companies went public and issued stock. This is a TWA certificate from 1930. (Courtesy of William C. Aitken.)

Benjamin O. "Benny" Howard stops for a photograph on Cicero Avenue at the United Airlines complex. The popular and ingenious aviator flew for UAL in the 1930s. (Courtesy of the San Diego Air and Space Museum Archive.)

Even during the Great Depression, air travel flourished at Muni, making it the "World's Busiest Airport." Here, in 1931, American Airlines Fairchild 100 Pilgrims load passengers at the new Sixty-second Street terminal. (Courtesy of the O'Carroll family collection.)

Technology took a grand leap forward when Boeing's all-metal 247 airliner was introduced in 1933. However, Boeing had ownership in United Airlines and was restricted to selling them exclusively to United. (Courtesy of Robert F. Zilinsky.)

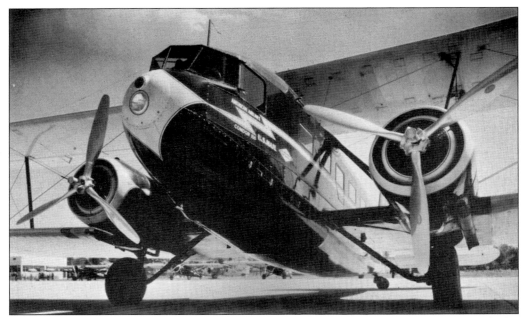

The Curtiss T-32 Condor, one of the most stately, luxurious aircraft of the early 1930s, had a maximum cruising speed of 176 miles per hour and flew with American and Eastern. This Condor awaits startup at the American Airlines hangar. (Courtesy of Robert F. Soraparu.)

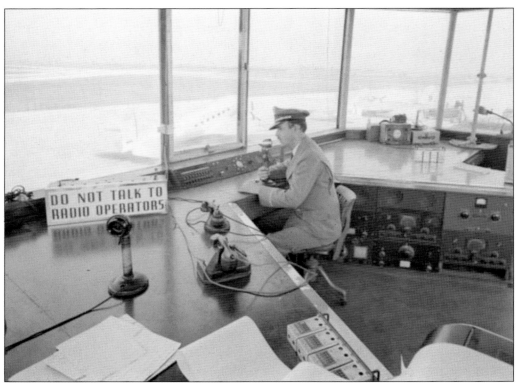

A busy tower controller uses a two-way radiotelephone to speak to pilots within the airport traffic area. Radio communications began in 1933. (Courtesy of Patrick Bukiri.)

Scores of spectators at the Sixty-second Street terminal line the ramp as passengers board two American Airlines Curtiss T-32 Condors in the mid-1930s. (Courtesy of Robert F. Soraparu.)

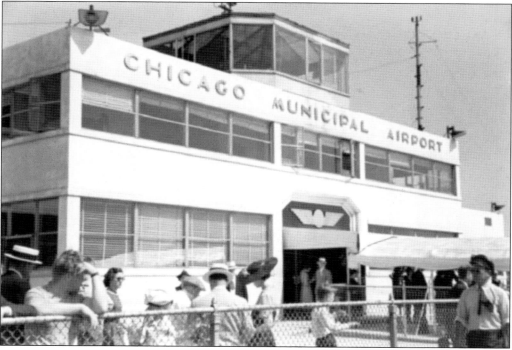

With the exception of the gentleman on the fence in the lower left of this photograph, the stylishness of dress is clearly evident at the terminal. For several decades, visitors and travelers dressed up to go to the airport and to travel by air. (Courtesy of Patrick Bukiri.)

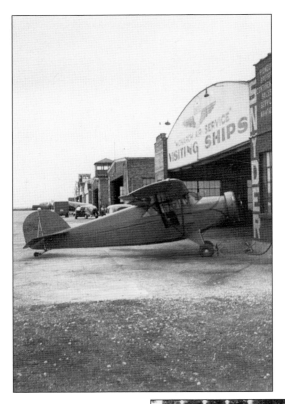

In the early 1930s, Pierce "Scotty" O'Carroll began Monarch Air Service in this hangar on Cicero Avenue. The hard-working, intrepid young Irishman lived the American Dream at the growing Chicago airport. (Courtesy of the O'Carroll family collection.)

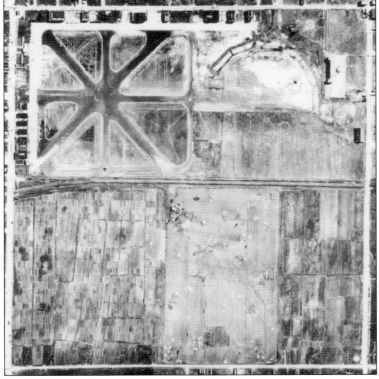

This 1933 aerial view of the square mile shows Buckmeier's Tavern at Sixty-third Street and Cicero Avenue (upper left). The Nathan Hale School appears at top right; two and a half blocks of grandstands taking shape along Sixty-third Street can clearly be seen, as well as the Army Transients hangar; a railroad track running mid-field; truck farms; and the Chicago Meadows Golf Course. (Courtesy of Patrick Bukiri.)

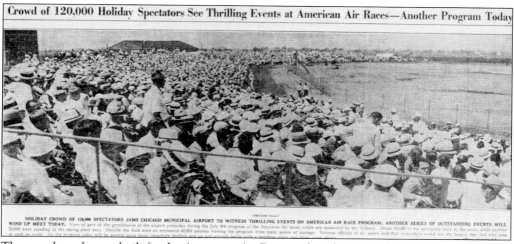

HOLIDAY CROWD OF 120,000 SPECTATORS JAMS CHICAGO MUNICIPAL AIRPORT TO WITNESS THRILLING EVENTS ON AMERICAN AIR RACE PROGRAM; ANOTHER SERIES OF OUTSTANDING EVENTS WILL WIND UP MEET TODAY. View of part of the grandstands at the airport yesterday during the July 4th program of the American Air races, which are sponsored by the Tribune. About 40,000 of the spectators were in the seats, while another 20,000 were standing in the racing plant area. Outside the field were an estimated 60,000 persons viewing the program from many points of vantage. Veteran officials of air meets said that yesterday's crowd was the largest they had ever seen at such an event. On the program today will be several prize races, parachute thrillers and an anti-aircraft program.

The grandstands were built for the American Air Races, a four-day event that thrilled people from near and far, including visitors to the 1933 World's Fair. The event coincided with Independence Day celebrations. (*Chicago Tribune* photograph.)

A United DC-2 takes off to the northeast from the newly crowned "World's Busiest Airport." (Courtesy of Patrick Bukiri.)

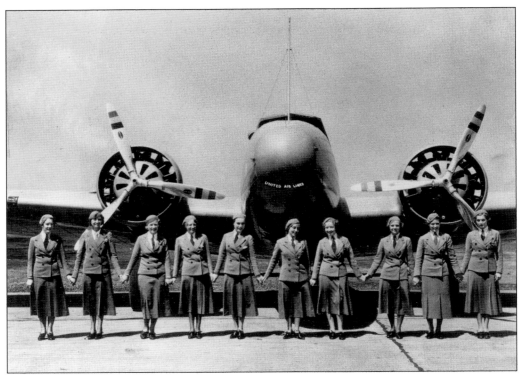

United Airlines stewardesses pose for the camera of Mike Rotunno, the legendary *Metro News* photographer based at Muni from the 1920s to the 1960s. Rotunno was on first-name terms with the most famous and celebrated names of Hollywood and Washington. He also did promotional photography for the airlines. (Courtesy of the Rotunno family collection.)

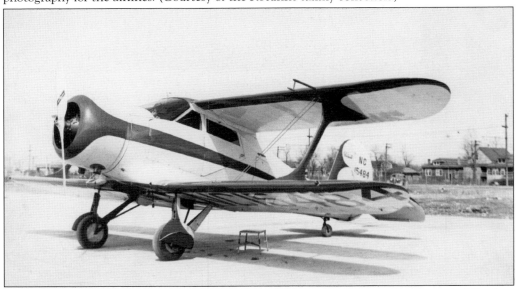

Scotty O'Carroll's Beechcraft B17L Staggerwing poses on the east ramp at Monarch. The fast, luxurious, 225-horsepower airplane carried up to five passengers and was custom-built by hand. Records indicate that TWA purchased this aircraft in February 1936. (Courtesy of the O'Carroll family collection.)

Three

GROWTH AND
GREAT ADVENTURE

Some 2,000 miles away, in Santa Monica, California, test flying was being completed on the Douglas DC-1, an airliner that would change aviation and the airlines forever. In a celebration at Grand Central Air Terminal in Glendale, Donald Douglas handed over the prototype DC-1 to TWA pilot D.W. "Tommy" Tomlinson. Douglas's production model, the DC-2, became widely used at Muni by TWA and American. From it came the final iteration, the DC-3, in 1936.

For as challenging as the DC-2 was to fly, the DC-3 was all the more docile and forgiving. American Airlines launched its transcontinental sleeper service with Douglas Sleeper Transports (DSTs), specially configured variants of the DC-3 design that allowed seats to convert into beds. In the DC-3, Douglas had an aircraft that would actually assist the airlines in becoming profitable. It featured 21 passenger seats, all-metal construction, a maximum speed of 207 miles per hour, and significant payload capacity. Also, it could fly from coast to coast with only three fuel stops. The Douglas DST popularized air travel in the 1930s, and the DC-3 totally revolutionized the airlines. Over its production history, Douglas would build 10,655 of the "Workhorse of the Airways."

Muni was two things: superior to every other airport in the nation and a showcase for the city of Chicago. In 1933–1934, Chicago was host to the world, and with the developments there, it became to aviation what Silicon Valley has been to the computer industry. Muni also had the latest technologies, two-way communication, precise instrument approach facilities for all-weather flying, and runway lighting. Yet on the same square mile resided a grade school, some 17 truck farms, two businesses, a golf course, and an Indian burial ground.

Muni's aerial show was captivating to observers, but to the airlines, it was business as usual. With competition already fierce between airlines, a far greater challenge arose in 1934 when the Roosevelt administration enacted new antitrust legislation based on its determination that the Spoils Conferences, held between the previous administration's officials and airline executives, had made airmail routes the exclusive domain of certain carriers. Overnight, the government abolished all airmail routes, and the airlines had to rebid every one. Newer carriers such as Chicago & Southern and the Minneapolis-based Northwest won routes formerly dominated by the "Big Four." Government regulation would continue without opposition for the next 44 years.

The year 1934 was one of adventure for Muni, Chicago, and aviation. One day in late January, a Ford Tri-Motor pulled up to the terminal and out stepped John Dillinger, public enemy number one. Throngs of admirers awaited him. He had been extradited to Indiana after being caught in Tucson, Arizona, and was now on his way to trial for killing a police officer in Indiana during a bank robbery. The same month, Dillinger escaped, stole the sheriff's car, drove off, and was apprehended. Finally, on Sunday, July 22, he was cut down in an alley next to the Biograph Theater on Lincoln Avenue in Chicago.

The Chicago Meadows Golf Course on Muni's mile closed that same year, and the city sought its land for further development of the airport. The clubhouse had been located near the center of the mile, close to the railroad track running mid-field. The following year, it was moved farther west, to Fifty-seventh Street near Central Avenue, just inside the airport perimeter road. It served as the residence of airport manager Lt. John A. Casey and his family until Casey's retirement in the 1950s.

By 1936, the airlines were warning that development of the full mile for airport use would be necessary because four-engine transports were already in testing. It was the wave of the future. Indeed, Tony Fokker had developed a perfectly viable four-engine transport, his F.32, as early as 1929, the demise of which was due to the notoriety Fokker received from the 1931 Knute Rockne crash and compounded by the Great Depression, which bankrupted many aircraft firms.

One of the Roosevelt presidency's hallmarks was the Works Progress Administration (WPA), which was active in the 1930s. Under a WPA grant, thousands of workers were hired to develop the square mile and extend parallel runways along its entire breadth. Plans for the airport also included an immense new boarding ramp and terminal area on Cicero Avenue to handle increases in passengers and aircraft. This was tough news for the many whose farms and livelihoods were displaced by new airport runways.

As WPA work began, some of the Nathan Hale School students, off for the summer, hung around and watched the workers level land for runways and buildings. One such student, Andrew "Turk" Cluck, remembers when workers were leveling several mounds of earth in an area where there had once been farms. Cluck and his buddies saw one of the workers unearth a cache of flint arrowheads and colored beads. The boys all knew that Indians had once roamed here—they had found an arrowhead or two before, but nothing like this. Cluck left that day with a shoebox full of arrowheads and beads, and a short time later, his suspicions were confirmed that the mounds being leveled were part of an Indian burial ground.

These were the years of air speed records, air racing, and Howard Hughes. On May 14, 1936, Hughes took off from Muni in a very fast, modified Northrop Gamma to fly the final, successful Chicago-Burbank leg of his speed-record attempt in 8 hours, 10 minutes, and 25 seconds. Hughes had made a $50 dinner bet that he could do this flight, and in winning the bet, he broke several standing records. He received the American Harmon Trophy as the world's most outstanding aviator of 1936, personally presented to him by Pres. Franklin D. Roosevelt. Hughes was also awarded the coveted International Harmon Trophy.

The airlines also competed for and broke records in nonstop cross-country events. But they broke records to win passengers.

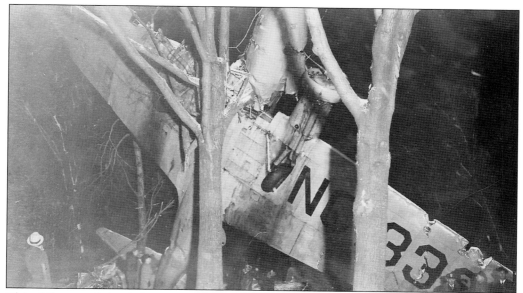

This airliner crash-landed in trees on December 12, 1934. United Airlines pilot David Behncke, later the president of the Air Line Pilots Association (ALPA), took off in a United Boeing 247 in solid instrument weather and headed west. With him were his copilot and a stewardess. Only 15 minutes out, over Aurora, his starboard engine began slowing and then quit. Behncke made a 180-degree turn, radioed the tower at Municipal, tuned into the Chicago Radio Range, and began riding the beam back in. His port engine also began cutting out and then quit, despite all attempts to keep it running. (Courtesy of Western Springs Historical Society.)

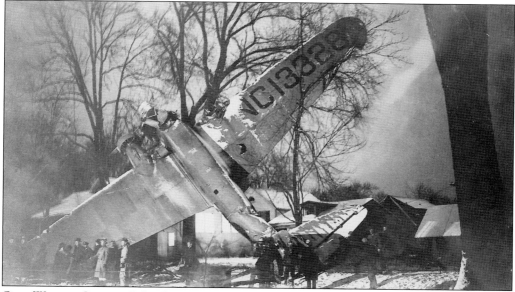

Over Western Springs, Behncke set up for a forced landing, attempting to head south to open land, but was unsuccessful. The airliner crashed into elm trees, tearing off the right engine, then slammed down tail-first and fell onto the port wing, leaving the aircraft pointing up crazily, with its nose in the trees. Severe icing in the clouds and precipitation had clogged the engines' carburetors. Ironically, Behncke was the only one injured when he fell 15 feet to the ground while exiting the airliner, breaking his arm and several ribs. (Courtesy of Western Springs Historical Society.)

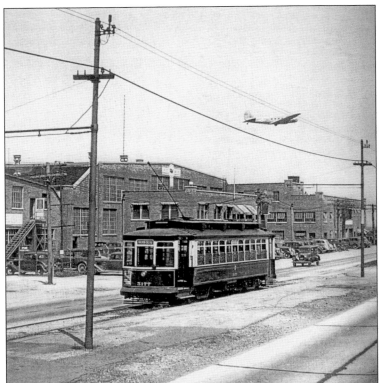

This photograph shows busy Cicero Avenue in August 1935 outside the United Airlines complex with a United Boeing 247 on climb-out. Within five years, the electrical streetcar wires were removed and electricity was rerouted to keep power lines and other tall obstacles away from airborne aircraft. (Courtesy of Robert F. Zilinsky.)

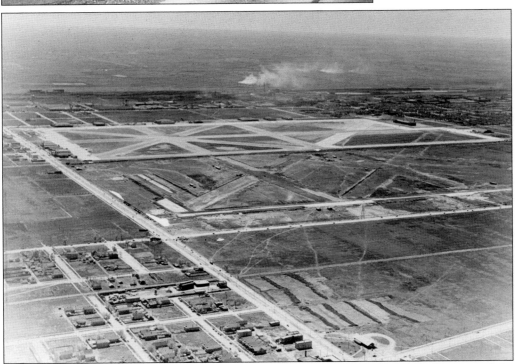

This mid-1930s southwestern view of Municipal Airport shows the degree of development of the full mile for airport use. (Courtesy of Patrick Bukiri.)

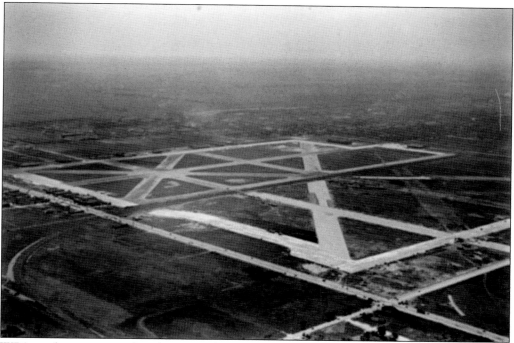

WPA workers were employed to turn the truck farms and the golf course into new runways. (Courtesy of Patrick Bukiri.)

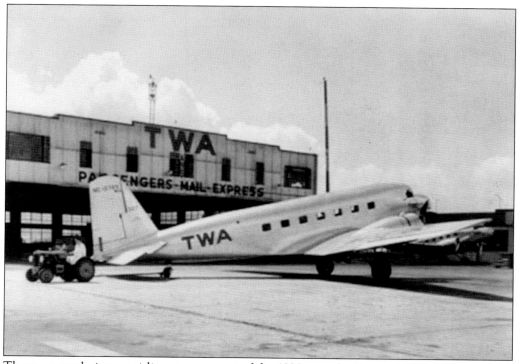

The most revolutionary airliner to come out of the 1930s was the Douglas DC-3. It followed the DC-1, the prototype, and the DC-2, seen here. The DC-3 improved vastly on the DC-2. (Courtesy of Robert F. Soraparu.)

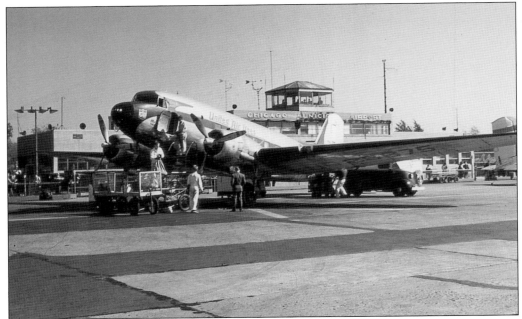

Known as "the plane that changed the world," the Douglas DC-3 was immediately exploited by the airlines. Before it was introduced in 1936, most airlines were still not profitable, but that quickly changed. (Courtesy of Robert F. Soraparu.)

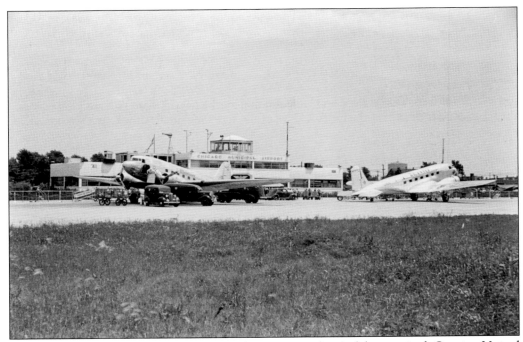

A pair of brand-new Douglas DC-3s graces the tarmac in front of the terminal. One is a United Mainliner, the trade name of UAL's piston transports. Miles away, over the fuselage of the Braniff ship, Two-Mile Tank is clearly visible. (Courtesy of Robert F. Soraparu.)

Four

THE LEGACY

Matty Laird and Benny Howard designed and built racing aircraft. They were also seminal in the development of aviation in the early decades. In the 1930s, Laird moved from his second Ashburn location to a more advanced facility on Sixty-fifth Street, two blocks south of Muni. Later, he moved back to Wichita, Kansas, to resume work he began there a decade earlier. Benny Howard and his partner, Gordon Israel, had finished a fast, roomy cabin racer, the DGA-6 *Mr. Mulligan*, in Kansas City, which they reproduced in Chicago as the DGA-7 *Flanigan*. It was built 3.5 miles east of Muni, around the corner from his room at the Troy Lane Apartments, at Sixty-third Street and Troy Avenue. *Mulligan* was built expressly to beat the pants off everyone else in the hallowed Bendix Trophy Race and build funding for the new Howard Aircraft Corporation, which began mass-producing the DGA-7. Howard also flew for United Airlines and was domiciled in Chicago.

Racing in the 1930s drew the best, fastest, most popular pilots in aviation. During a surprise fly-by at Wright Field in Dayton, Ohio, Howard clocked *Mulligan* at 350 miles per hour. With Gordon Israel as copilot, Howard then flew *Mulligan* in the Bendix Trophy Race of 1935 and won it hands-down, beating his friend Harold Neumann and a score of other well-known fliers. Several days later, Neumann flew *Mulligan* to a win at the coveted Thompson Trophy Race.

Mulligan had a Pratt & Whitney Wasp radial engine with a supercharger, a combination that put out 850 horsepower, and the aircraft was designed to fly the racecourse nonstop at high altitude. For 1936, *Mulligan*'s chosen copilot was Maxine "Mike" Schoen Howard, a pretty 25-year-old Kansan with her pilot's license. She had learned to fly in 1935 and had flown her check ride in Harold Neumann's Lambert Monocoupe. She was also Howard's wife, and they were the odds-on favorites to win the 1936 Bendix New York–Los Angeles Race.

During the Bendix race, *Mulligan* easily held the lead with an average speed of 250 miles per hour, even with a fuel stop in Kansas City. Suddenly, at just short of two hours to the finish line at Los Angeles's Mines Field, a propeller blade failed. *Mulligan* was extremely strong structurally, and the engine remained attached, but the massive flywheel effect from the missing blade violently wrenched the aircraft over onto its back. Howard's head smashed against a steel cockpit support. Dazed and barely conscious, he was able to gain control as the engine stopped, while his wife

kept the blood from his wound out of his eyes and kept the aircraft flying. They crash-landed in a small clearing between the mountains near Crowpoint, New Mexico, and were seriously injured. Rescued by a local tribe, the Howards were treated and then spent months recovering from their painful injuries.

Benny lost a leg, and Mike spent many months in recovery. With zero winnings and a mountain of medical expenses, financing for the new business was nonexistent. However, the persistent Benny Howard continued flying for United Airlines; Mike eventually recovered and flew with him in a historic US tour to introduce Douglas Aircraft's newest design. Howard Aircraft was formed in 1937 and then sold in 1941, moving to St. Charles, Illinois. Howard Aircraft's runways across Powis Road from the wartime factory eventually became DuPage County Airport.

The first Howard Aircraft shop in that grocery store on Troy Avenue helped build another career. The shop was constantly visited by eight-year-old Jack Dusak, who lived in an apartment above the factory. Dusak later remarked, "I used to see Mike go up on the roof of the Troy Lane Apartments and sun herself. Benny made sure he'd fly over in one of the United ships when she was up there."

When Howard subsequently moved his operation to Matty Laird's former facility at 5301 West Sixty-fifth Street, Dusak became a resident visitor there as well. Dusak joined the Army Air Corps, was an aircraft mechanic for TWA at Muni, and eventually became a private pilot. Though retired from TWA, Jack Dusak continues to conduct aircraft inspections and certifies manufactured aircraft parts and subassemblies. As it did to so many other Chicago aviators, aviation smote Jack for life.

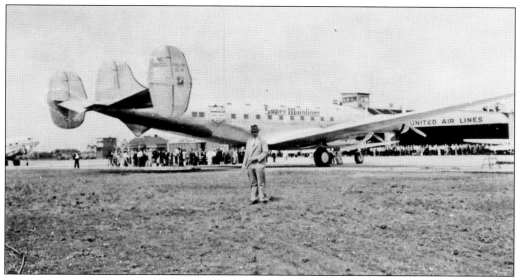

Benny Howard, pilot of the Douglas-designed DC-4E, poses in front of the new airliner at Muni in 1939. When Benny and Mike Howard moved from Chicago, Benny went to work with Douglas Aircraft as its test pilot. (Courtesy of William C. Aitken.)

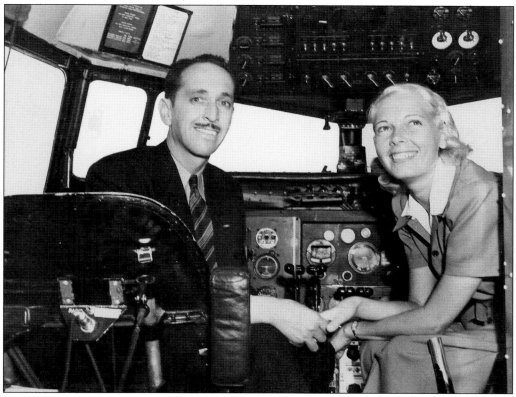

Benny Howard, 35, and his wife, Maxine "Mike," 26, smile from the cockpit of the DC-4E during its 1939 airport tour. Even after their 1936 brush with death during the Bendix race, both pilots continued flying and making history. (Howard Aircraft Foundation photograph, courtesy of John and Robert Dusak.)

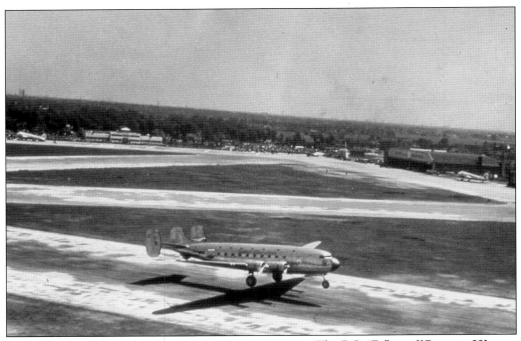

The DC-4E flies off Runway 22L after its tour stop at Muni in 1939. Douglas made significant changes to the DC-4 design, and then the DC-4E was sold to the Japanese, who reverse-engineered it. The result was the unsuccessful Nakajima G5N bomber. (Courtesy of John and Robert Dusak.)

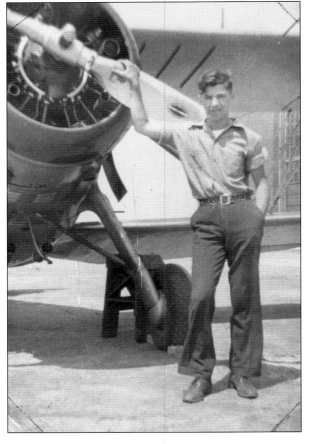

Fourteen-year-old John "Jack" Dusak poses with a civilian biplane, likely a Waco, in front of the American Airlines maintenance facility on Sixty-third Street, halfway between TWA's and American's main hangars. Dusak joined TWA in 1942 at age 16 after a stint in the Army Air Corps. (Courtesy of John and Robert Dusak.)

Five

PROGRESS AND CHALLENGE

By 1938, all the transcontinental lines had been direct beneficiaries of the revolution in air travel and profitability that the DC-3 had started. Additionally, aircraft companies were designing four-engine airliners for over-water range, far greater speed, and increased seating capacity. Boeing had just certified its mammoth four-engine 314 flying boat and was testing the 307 Stratoliner, an advanced, pressurized land plane possessing attributes of the B-17 heavy bomber. Out of the 10 produced, TWA purchased five; in 1940, the Stratoliner was "the only way to fly," and planes now competed directly with railroads for passengers.

Concurrently, a funded consortium of several major airlines, headed by United, approached Donald Douglas requesting a new, four-engine transport capable of carrying twice the number of passengers as the DC-3, at faster speeds, with greater range, above the weather. Douglas responded with the DC-4E, a prototype aircraft. The unusual-looking DC-4E included innovative new features for a land-based airliner, including a low-profile triple tail, a tricycle gear, and its own auxiliary power units (APUs) for engine startup. Pressurization was also planned for DC-4 production models.

United rolled out and promoted the new ship in 1939 on a highly publicized nationwide tour with pilots Benny and Mike Howard. But after thorough evaluation, the DC-4E was determined to be impractical. Significant design changes, including a conventional tail, resulted in the unpressurized, robust, and popular DC-4, a staple of the military and many postwar airlines.

Meanwhile, in Burbank, California, TWA's Howard Hughes and William "Jack" Frye, along with Lockheed designer Clarence "Kelly" Johnson, watched Lockheed's own triple-tailed, tricycle-geared, four-engine aircraft, the Model 49 Constellation, finish certification. Unlike the DC-4E, this one was a keeper. Although some saw limited wartime use as military C-69s, none were delivered to the airlines until 1945. Many C-69s were converted into civilian transports and became 049s.

Between 1929 and 1939, Muni flew 2,190,769 passengers and hosted 697,407 flights. In 1939, the field occupied the full square mile, boasting nine runways, but it was still not quite ready to handle the largest aircraft.

Muni tied the East Coast and West Coast together while its own northern and southern halves remained divided. The busiest airport had the busiest rail line in the world running through it,

and there was no activity on the field north of Fifty-ninth Street. The Chicago & Western Indiana Railroad had perpetual right-of-way, and at any given time, the smoke from one of the C&WIRR's steam locomotives could be seen traversing the square mile's midsection.

In 1939, American Airlines pilot Wally Dorn began flying DC-2s and DC-3s out of Chicago. "In those days," he shared, "I remember the runways having carbon arc searchlights that would shine right down the active runway at night. Before that, they used flares to light the runways."

The airport was also useful for other things besides flight operations. Hangars doubled as rendezvous spots, and Dorn remembers one American Airlines captain in the 1940s who arranged to meet a lady friend, likely a stewardess, in some clandestine location at the airport. After they had landed, the captain was often spotted motoring off westbound into the darkness, straight down the south ramp. It could have been American's maintenance hangar or an office closer to the Army Transients hangar. Dorn did not have a clue—and no one asked the captain about it.

William C. "Bill" Aitken began his career at Muni as an aircraft mechanic with TWA in 1940. Many aircraft mechanics were graduates of Aeronautical University, an aviation school on Michigan Avenue in downtown Chicago that trained pilots and mechanics. After World War II, AU became a part of the Illinois Institute of Technology.

Aitken recounted the predicament of some pilots flying into Muni in 1940 and 1941. "It wasn't much fun with that railroad track midfield," Bill said. "We used to watch those Chicago & Southern Lockheed 10s, and a few of them would land on the runway north of the tracks. Either the tower assumed the pilots knew about the tracks or they were too busy to warn them. They'd land and you could see them stranded way out there on the north side. Sometimes they'd come right up to the tracks and discover they couldn't cross them. So they'd do a 180 and wait for permission to crow-hop over the tracks, and get to the terminal." Aitken added with a laugh, "I remember a couple of those L-10s landing long and banging into the berm that the track sat on. That sure stopped them."

By 1941, the nation knew that war loomed. The country was digging itself out of a depression, US airline captains were finally earning a good, steady living, and copilots were being promoted regularly. It did not feel so much like a depression anymore. But it felt like war.

In Washington, President Roosevelt was keenly aware that the nation's busiest airfield had a railroad track running down the middle of it, and there was a good chance the airport would very soon be going military. Aggressive discussions took place with the Chicago & Western Indiana Railroad to reroute its Belt Railway track north of Fifty-fifth Street. With war hovering malevolently on the horizon, the US government became involved, and by act of Congress, the tracks were relocated north of the field.

A track-moving ceremony was held at Fifty-ninth Street in the middle of the airport on Thursday, May 1, 1941. Present were Belt Railway executives, Chicago mayor Edward M. Kelly, airport manager John Casey, future airport manager Mike Berry, state's attorney John Boyle, and a host of cameramen and newspaper reporters. On June 30, the airport was officially rededicated with more than 350,000 in attendance. The rail bed, leveled and paved over, was now Runway 9L/27R. Parallel takeoffs and landings on modern runways close to or exceeding a mile in length were now possible in any cardinal direction and for any type of aircraft.

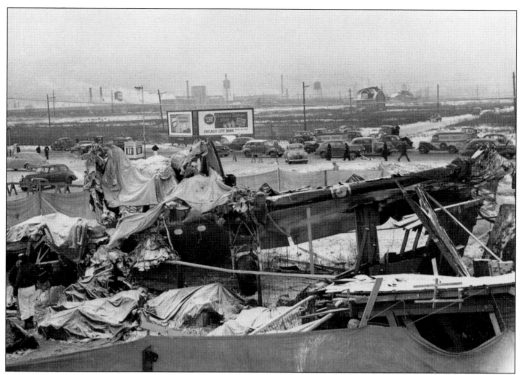

On December 4, 1940, tragedy occurred at 6350 South Keating Avenue when a United Airlines DC-3, NC25678, inbound to Runway 31, stalled and crashed. While flying in icing conditions, the aircraft accumulated a load of ice on the wings, increasing its weight and stall speed. Ice on the windshield also impaired the pilot's vision. During his second attempt following a missed approach, the pilot did not maintain sufficient airspeed on final to avert a stall, and 10 lives were lost. (Courtesy of Patrick Bukiri.)

William C. "Bill" Aitken, a veteran of Midway Airport and the head day mechanic for TWA during the piston era, works on one of a DC-3's giant Wright Cyclone R-1820 radial engines around 1940. Bill was a graduate of Aeronautical University, a main educator of TWA maintenance technicians, many of whom worked well into the jet age after the major airlines left Midway for O'Hare Airport. (Courtesy of William C. Aitken.)

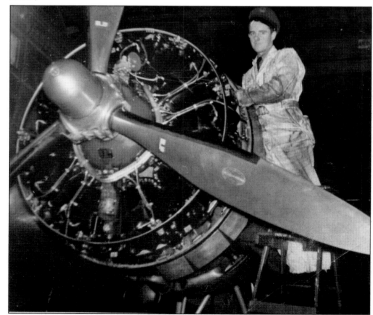

Pierce "Scotty" O'Carroll and his family practically lived on the east ramp at Muni in the 1940s. Sheila, the baby daughter of him and his wife, Rose, grew up with the airport. (Courtesy of the O'Carroll family collection.)

This 1937 Stinson SR-10 Reliant was Scotty O'Carroll's *Aristocrat Lady*, complete with cowling and tail art. During a flight to Memphis, the engine failed, and O'Carroll had either dense forest or Missouri's White River to choose from for a forced landing. He decided to take a dip, and the aircraft was rescued, repaired, and flew again. (Courtesy of the O'Carroll family collection.)

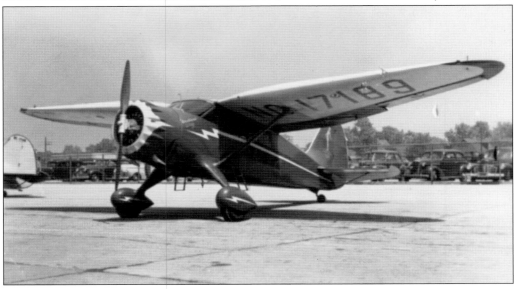

A 1940s TWA captain snapped this left-seat view of the Chicago airport as his DC-3 flies the pattern at Muni. Shown mid-field is the new Runway 9L/27R, where the railroad track had been. (Courtesy of William C. Aitken.)

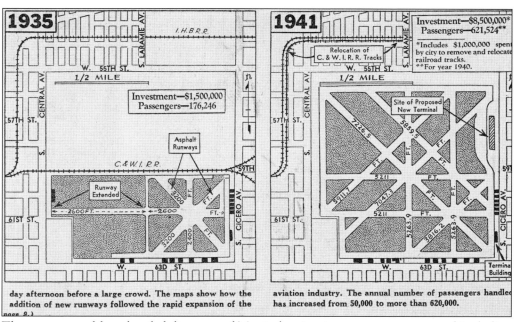

day afternoon before a large crowd. The maps show how the addition of new runways followed the rapid expansion of the *page 9.)*

aviation industry. The annual number of passengers handled has increased from 50,000 to more than 620,000.

These are two of four detailed diagrams of Muni, showing improvements up to and including 1941. Since opening in 1926, the adolescent airport had already undergone monumental change. (Courtesy of Patrick Bukiri.)

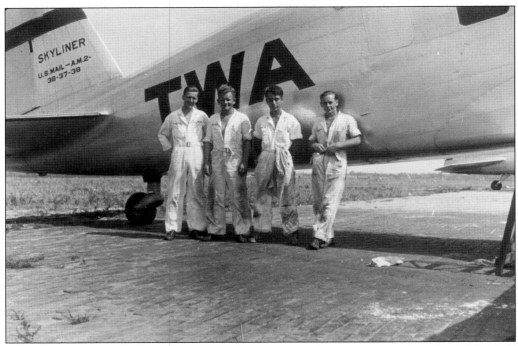

A TWA maintenance crew poses at one of its DC-2s in the early 1940s. Note the "U.S. Mail" embroidered on the uniforms. (Courtesy of John and Robert Dusak.)

averages you have nothing to actually worry about — you should hear from him before the month is out if you haven't already heard.

I hardly believe he has had time to get out here yet. If you dont hear from him in the next few days let me know and I'll try to locate him through the employment officers at the factories here. There are fifty thousand people employed in the aircraft business here and that is the only way I would have to locate him. Before he could get a job here he would have to get a birth certificate so you might check up on that angle.

I hope you have heard from him by now but if not please do not hesitate to call on me for what I may be able to do

Sincerely,
Ben O. Howard

Benny Howard took the time to write a reply letter to the distraught mother of Jack Dusak, who had run away from home in search of aviation adventure in 1941. While she thought her son had run to California with the Howards, Benny assured her that Jack was not with him, and that all boys think of running away. He let her know the boy would return, which Jack did. He later joined both the Air Corps and TWA. (Courtesy of John and Robert Dusak.)

Six

WAR AND PEACETIME

On Sunday, December 7, 1941, the Japanese navy attacked the US naval fleet at Pearl Harbor, Hawaii. The following day, President Roosevelt made his official declaration of war. A week later, the Department of Commerce gave the US military full authority over all of Muni's operations. The longer runways had come just in time.

Multiple movements of military observer, trainer, transport, and bomber aircraft now interacted with civilian traffic, and Muni was now a military airfield. Chicago's small cluster of military fields and large number of outlying auxiliary fields remained busy throughout the war. Arlington Field, in what is now Rolling Meadows, even housed and utilized German prisoners of war. Training flights were regularly conducted to far-northwest suburban landing fields with names such as Prall's Pit and Murphy's Circus. Nonmilitary flying continued at Ashburn, Harlem, Howell, Sky Harbor, Hinsdale, Stinson, Elmhurst, Sky Haven, and other civilian airports.

The airlines prospered during the war: TWA flew 40 million miles just for the Army and supplied the first North Atlantic and South Atlantic routes. However, at least two tragedies marred wartime Muni. One involved a popular visual checkpoint for inbound fliers: Two-Mile Tank, a gigantic, 450-foot-tall gasholder for People's Gas, Light & Coke Company at Seventy-third Street and Central Park Avenue, which held 18 million cubic feet of illuminating gas. TWA captain Wally Dorn remembered the story of Army B-24 Liberator S/N 42-7053, which was on a practice navigational flight out of Fort Worth, Texas, on May 20, 1943, carrying 12 airmen. Dorn explained that on instruments in zero visibility, the pilot had called Muni tower and received clearance to land on Runway 4C. On arrival, the pilot, unable to see the field, circled back for a second approach but again declared a missed approach. Afterward, the aircraft was observed flying at 50 feet above the ground, close to the huge tank. A worker at the location then saw the bomber fly directly into the tank at the 200-foot level, and the titanic explosion instantly immolated the structure, the airplane, and the crew. Even through the dense fog, eyewitnesses saw flames shoot hundreds of feet into the air.

In the 1940s, arriving airplanes often taxied to company or military hangars in lieu of the diminutive Sixty-second Street terminal. "One day in the dead of winter," Jack Dusak recounted, "This TWA DC-3 came in all iced up. Who pulls up in it but Jack Frye, with his head out the side

window. I'm standing at the gate; the passengers get off and they're all wrapped in blankets. But this one passenger gets out and he's over there looking at the leading edge of the wing. I said to him, 'I'm sorry but you're going to have to get over there behind the fence' (where the passengers had to stand). One of the crew came up to me and said, 'Do you know who you just chased off the ramp? That was Jack Frye!' "

By 1945, the airport was handling 80,000 takeoffs and landings and 1.3 million passengers annually—and the pace did not let up once the war ended. In 1945, the Civil Aeronautics Administration (CAA) certified TWA, American Airlines, and Pan American for international flights to Europe, boosting passenger numbers even more. On February 5, 1946, TWA inaugurated its transatlantic service with Lockheed 049 Constellation NC86511, the *Star of Paris*. The flight from New York to Paris-Orly via Gander and Shannon Airports took 16 hours and 21 minutes. Sadly, 15 years later, this celebrated aircraft met a tragic end 10 miles west of Midway Airport in a cornfield.

Postwar airline traffic surged exponentially. The price of air travel, which had been prohibitively high for most since the 1930s, was much more affordable and included different levels of service. Aviation had matured, and America's postwar travelers now wanted to sample the speed and romance of flying to their destinations.

During Muni's prewar expansion, planners were already aware that Muni was running out of room. That point was brought home in the exhaustive Chicago Aero Study of 1946, which contained data and findings on all area airfields. The Master Plan of Chicago in 1948 concluded that Orchard/Douglas was the optimal site for a new, larger airport.

Meanwhile, Muni flourished. An expansive new north terminal was completed in 1948. With it came Marshall Field and Company's elegant Cloud Room, a magnificent second-floor restaurant offering spectacular views of the entire airport and sumptuous cuisine reflecting the tastes and elegance of a discriminating Air Age public. Statesmen, Hollywood celebrities, Chicago notables, and world travelers dined there. Another extremely popular Marshall Field venue, the Blue and Gold Café, was on the first floor.

In 1949, veterans' groups petitioned the city to rename Muni in honor of the Battle of Midway, one of the most decisive US victories of World War II. On June 22 of that year, Muni became Chicago Midway Airport by a unanimous city council vote.

By 1950, Midway was the hub for 15 scheduled airlines, serving 3,820,165 air passengers and 234,331 aircraft movements. In 1952, Midway reached close to six million passengers, and the square-mile airport's numbers continued their upward growth throughout the 1950s.

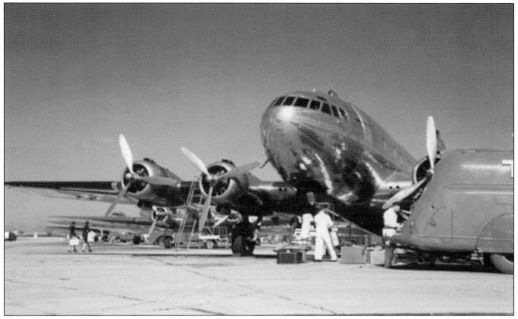

Boeing's first four-engine airliner was a beauty. The 307 Stratoliner was pressurized and possessed the strength and technology of the new heavy bomber, the B-17. TWA purchased five Stratoliners in 1940, two of which are seen here boarding at Muni on October 10, 1941. (Courtesy of Robert F. Soraparu.)

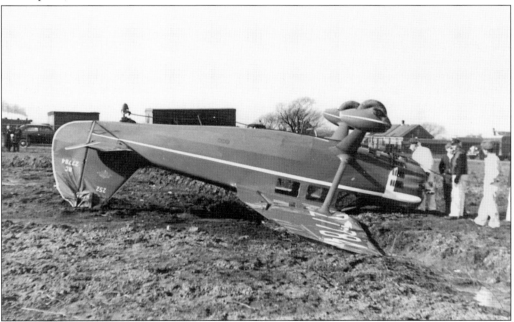

A TWA Stinson Reliant on an instrument-training flight approached Muni from the west on Saturday, December 6, 1941. The aircraft inadvertently landed in a dirt field and flipped over when the pilot misjudged his distance from Muni and his altitude above the ground. The pilot's shaken and distraught demeanor was certainly eclipsed by that of the entire nation the following day, Sunday, December 7, 1941, when Pearl Harbor was attacked. (Courtesy of William C. Aitken.)

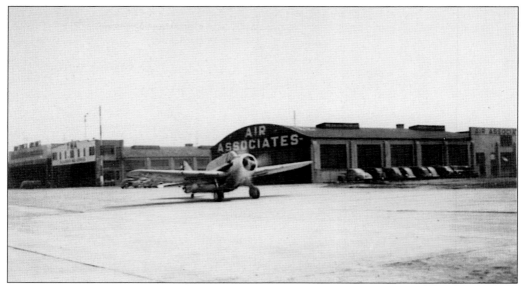

Training activity soared in December 1941. Muni saw all manner of military iron, including observer ships like this North American O-47. Their center of activity was at the new 108th National Guard Observer Squadron facility on the south ramp, which opened in December 1940. (Courtesy of John and Robert Dusak.)

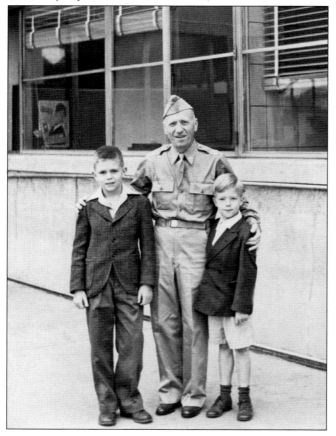

Willis Heath Proctor (center) poses proudly with his sons Bill (left) and Bob (right) early in World War II at the Muni terminal. At the time, Proctor, a pioneer airline pilot for American, was also the commander of Mitchell Field in Milwaukee. He was likely on his way back there when this photograph was taken. He later served as commander of La Guardia Airport in New York, and in 1944, he was called to the China-Burma-India (CBI) theater of war. (Courtesy of Jon Proctor.)

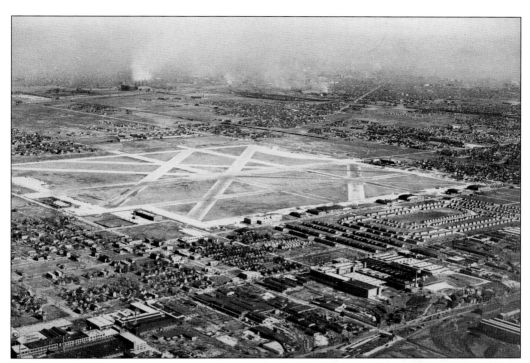

A close-up of this wartime photograph looking northeast at Muni reveals a bevy of military aircraft parked at the Army Transients facility, including what is either a Consolidated-Vultee (later Convair) B-24 Liberator or a C-87 Liberator Express. A large transport has also skidded off the runway mid-field. (Author photograph.)

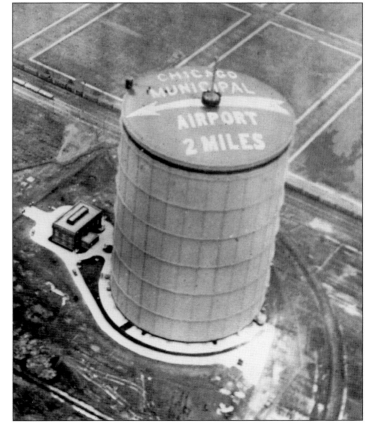

Two-Mile Tank was a visual checkpoint for pilots flying into Muni until an inbound Army B-24 Liberator flew into it in dense fog on May 20, 1943. The explosion destroyed the tank and incinerated the aircraft and 12 servicemen but spared the building, seen here, which remains today. (Courtesy of Patrick Bukiri.)

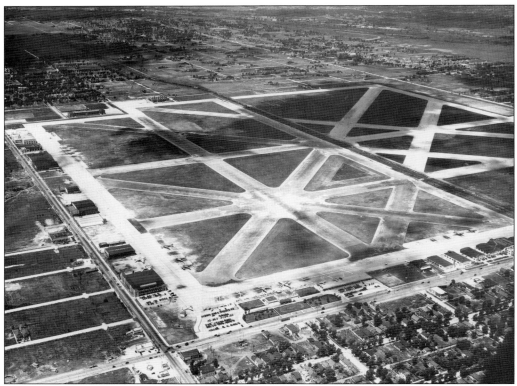

This photograph shows an all-but-complete Muni, with Sixty-third Street and Cicero Avenue in the lower left. A railroad track divides the field, and a freight train is seen making its way eastward across Central Avenue. The northern half of Muni was virtually unusable until the track was removed by an act of Congress in 1941. (Author photograph.)

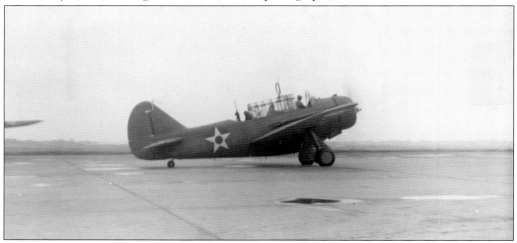

An amazing array of powerful military aircraft served Muni during World War II, including O-38s, the BT-9, BT-13, PT-17 and AT-6 trainers, and occasional B-17 Flying Fortresses and B-24/C-87 Liberators. In June 1942, Douglas began constructing a new plant 18 miles northwest to produce C-54/R5D versions of the redesigned DC-4 airliner. Orchard/Douglas (ORD) produced 654 airplanes, and the nearby Dodge plant, at Seventy-fourth Street and Cicero Avenue, assembled Wright R-3350 radial engines for the Boeing B-29 Superfortress. (Courtesy of John and Robert Dusak.)

One morning in 1944, young Ruth Van Etten showed up at the Sixty-second Street terminal to begin training as a tower controller. Having just completed Women's Army Service Pilot (WASP) training, she was a certified pilot, but the program was through accepting candidates by that time. Her tower role was trying in the male-dominated environment; another woman had washed out, but Van Etten persevered. (Courtesy of Ruth Osgood.)

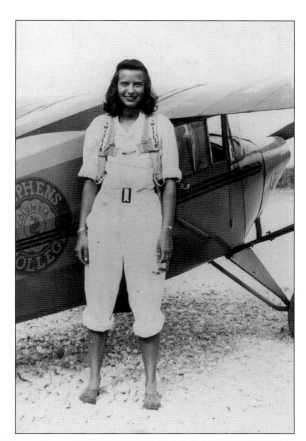

World War II proved that, with the absence of men, women could work their jobs. As both a pilot and a tower controller, Ruth Van Etten was a trailblazer, not only at Muni but also for all women in aerospace professions. (Courtesy of Ruth Osgood.)

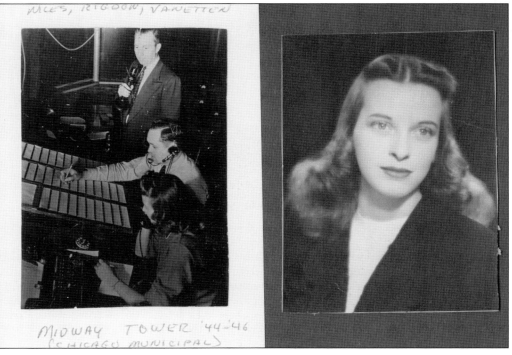

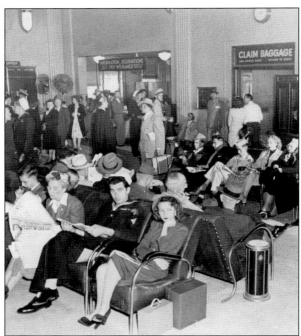

Business was great for the airlines at Muni during the war; passenger numbers as well as flight operations climbed exponentially. This photograph shows how busy the small terminal was in 1945. (Courtesy of Robert F. Soraparu.)

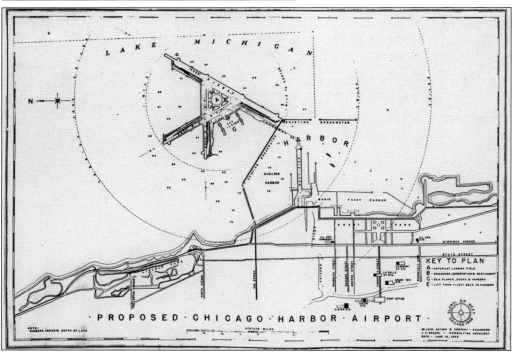

City and airline planners had long known that there was a physical limit to Muni's growth. Enter the Comprehensive Study Relating to Aeronautical Facilities for Metropolitan Area of Chicago Projected to 1970, known colloquially as the Chicago Aero Study of 1946. Data, diagrams, and artists' conceptions of airfield facilities helped provide possible solutions, all of which led to the 1948 Master Plan of Chicago. This June 1945 diagram of an "airport in the lake" from the 1946 report represented the most unique solution. (Courtesy of William Ritchie.)

Many of Hollywood's biggest stars visited Muni. Here, actor Joe E. Brown smiles his famous smile near Monarch Air Service's charter shack in 1946. (Courtesy of William C. Aitken.)

Francis "Whitey" Ford, also known as "the Duke of Paducah," was a banjo-playing country comedian popular in Chicago radio markets in the 1930s. In 1942, he became a national star, regularly appearing on Nashville's *Grand Ole Opry*. TWA mechanics hail their hero in this photograph as Ford steps off a TWA Stratoliner at Muni. In a perfect salute to the Duke, Bill Aitken (second from right) thumbs his nose. (Courtesy of William C. Aitken.)

Actor and flier James Maitland Stewart relaxes with director H.C. Potter underneath the port wing of a DC-3 at Monarch during shooting of the movie *You Gotta Stay Happy* in 1946. Joan Fontaine, Stewart's leading lady in the movie, is likely the lady at left. (Courtesy of William C. Aitken.)

In the romantic comedy, Stewart played Marvin Payne, an aspiring flier with a startup air carrier. A hammy TWA ground crew lounges in the background of this photograph. (Courtesy of William C. Aitken.)

Jack Dusak (right) and TWA mechanic Frank Zawilla pose under the left main gear of a TWA DC-3 at Muni in the 1940s. Zawilla was killed in an accident after the airline transferred to O'Hare in 1960. Dusak recalled, "He used to park the airplanes in a row at O'Hare. We had auxiliary power units we called 'leeches' used to start the engines; they were like trucks, with tools in the back. Frank was standing behind the leech and the roar of the jet engines drowned out everything else, so you couldn't hear anything but jet noise. And the truck backed up, right over the guy, and crushed him. I was the one who had to tell his wife." (Courtesy of John and Robert Dusak.)

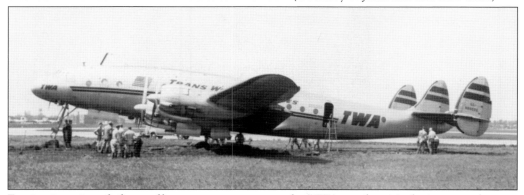

Extricating aircraft from off-runway messes, part of a TWA mechanic's duties, was always a challenge. Here, in the late 1940s, TWA 049 Constellation N86506, Fleet No. 551, *Star of Dublin*, is being removed from the muck. (Courtesy of John and Robert Dusak.)

The TWA day crew poses for a photograph at the south ramp facility. Head mechanic Bill Aitken stands to the immediate left of the driver. (Courtesy of William C. Aitken.)

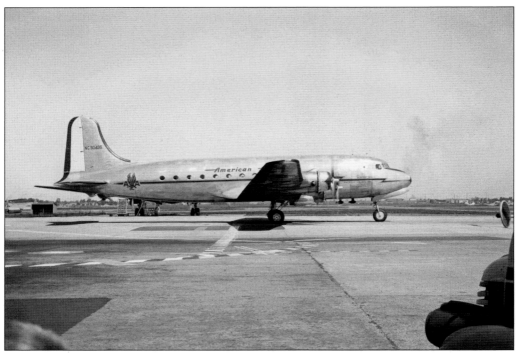

DC-4 NC90435, a postwar convert to civilian configuration, is seen on the south ramp in 1947, piloted by Capt. Willis H. Proctor. Originally, Captain Proctor had transferred to Muni from Cincinnati on November 1, 1935, to fly the DC-2. After the war, he came back to Muni, where he remained until 1957. From 1950 to 1957, he served as the head of pilot training at the new north ramp American Airlines hangar. His office was on the west edge of the two hangars in the administration area. (Photograph by Bill Proctor [son of Willis Proctor], courtesy of Jon Proctor.)

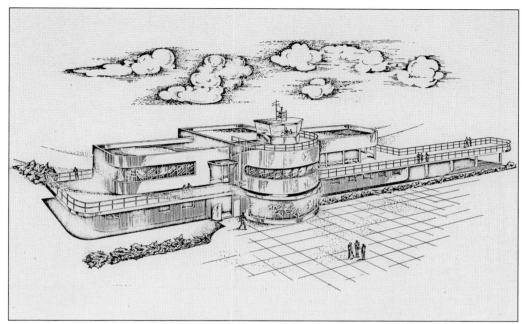

Another highlight of the Chicago Aero Study of 1946 was this drawing of a larger airport terminal building. Some of the main elements were utilized in the new north terminal, which was completed in 1948. (Courtesy of William Ritchie.)

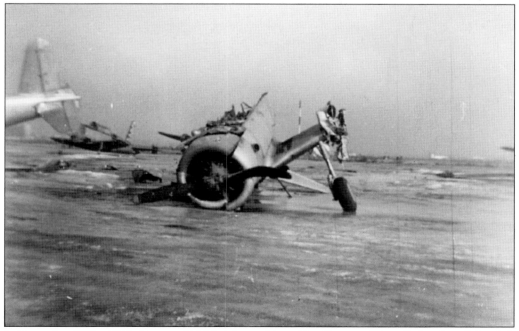

In December 1947, a Slick Airways C-46 freighter taking off on Runway 22L stalled and crash-landed, destroying several aircraft parked in front of the Air Guard Hangar on the South Ramp—among them, this Vultee BT trainer. Although it appears to have taken the brunt of the hit, two-thirds of the Slick Commando's left wing was sheared off in the crash. (Courtesy of Edward Cermak.)

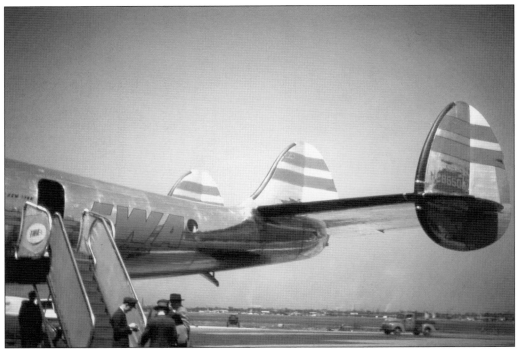

Unavailable to the airlines until after World War II, the Lockheed 049 Constellations began to appear en masse at Muni as fast as Lockheed could convert them from military ships to airliners. Most went to TWA and Pan Am. Here, NC86500, Fleet No. 500, boards at the Sixty-second Street terminal. (Courtesy of William C. Aitken.)

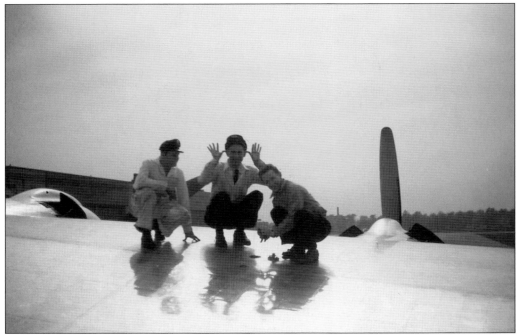

Bill Aitken and two TWA linemen clown around atop the wing of this 049 Connie in the late 1940s. (Courtesy of William C. Aitken.)

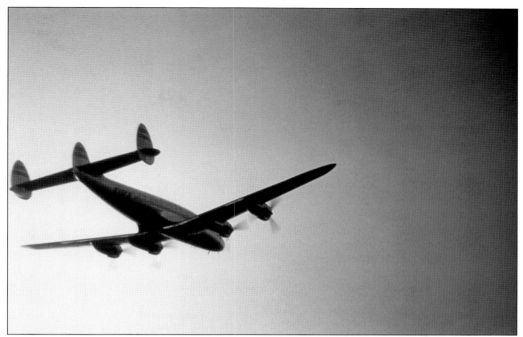

A TWA 049 Constellation roars off the runway at postwar Muni. This photograph, shot in color, showed a red taillight, indicating an airliner recently converted to civilian use from military configuration. Soon afterward, all civilian planes had white taillights only. (Courtesy of Robert F. Soraparu.)

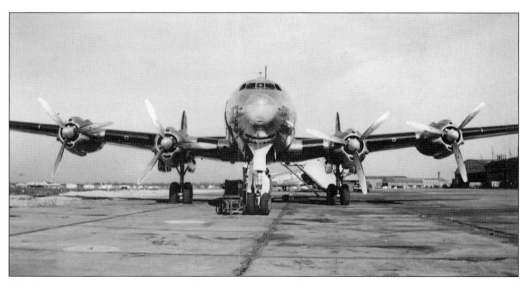

The business end of a 049 Constellation was beautiful on any ramp at Muni. Connies looked graceful just standing still. (Courtesy of John and Robert Dusak.)

Sheila O'Carroll (left) and her cousin Annamae Sullivan stand before a verdant, garden-like setting at the south terminal in 1948. O'Carroll used to skate on the ramps and play around the water puddles near the giant directional runway markers. She would even learn to drive at Midway. These were salad days for all ages; one hardly needed to be in the air to have fun at the airport. (Courtesy of the O'Carroll family collection.)

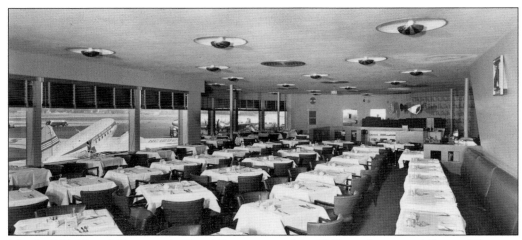

Marshall Field and Company's Cloud Room opened in 1948 on the second floor of the new terminal. The exclusive restaurant hosted Hollywood celebrities and every caliber of dignitary, including Eleanor Roosevelt and American presidents. (Courtesy of Robert F. Soraparu.)

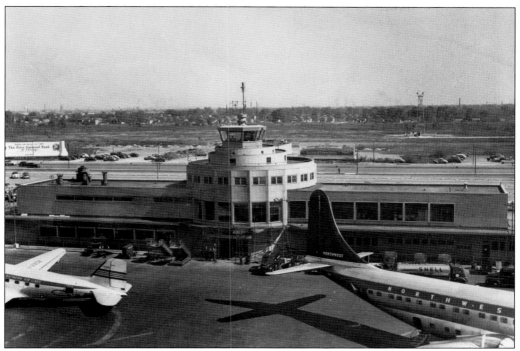

This August 1949 view of the north terminal and loading gates was taken around the time Muni was rechristened as Chicago Midway Airport. A Chicago & Southern DC-3 and a Northwest Boeing 377 Stratocruiser are parked in the foreground. (Courtesy of Robert F. Soraparu.)

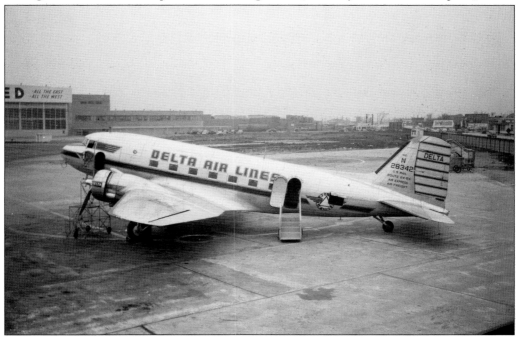

This Delta DC-3 is being preflighted near Fifty-fifth Street and Cicero Avenue in 1949. In the background, Cicero Avenue is being widened for better traffic flow, airport parking, and easy access to the postwar Midway Airport. (Photograph by Bill Proctor, courtesy of Jon Proctor.)

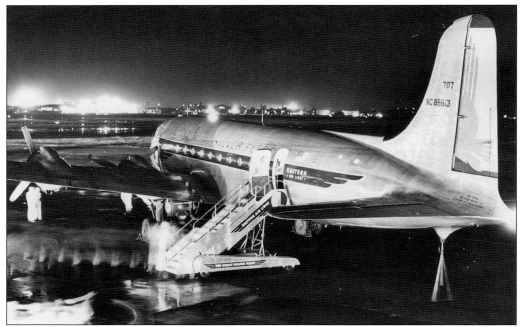

The civilian Douglas DC-4 could handle 50 passengers and travel at 245 miles per hour. Moreover, Douglas was introducing the DC-6, a larger version of the DC-4 with more power and range. As the south ramp lights glisten in the night a mile away, this Eastern DC-4 prepares for boarding. (Courtesy of Robert F. Soraparu.)

Robert F. "Bob" Zilinsky (left) and his friend Ed Janda pose in front of the Piper J-5 Zilinsky learned to fly out of Harlem Airport in the late 1940s. Zilinsky went on to become the chief mechanic for American Airlines at its north ramp facility at Midway. He was later promoted to flight engineer on the airline's DC-6s. He retired as a first officer flying the American DC-10. (Courtesy of Robert F. Zilinsky.)

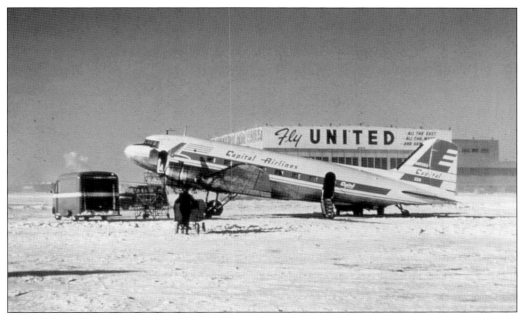

A Capital Airlines DC-3 prepares for flight near the United Airlines "cattywampus hangar," as Jack Dusak refers to it. The large hangar paralleled Runway 22 on the bias to all other buildings on the airport. The hangar, built in 1946, later became the home of Eastern Air Lines. TWA also leased space in the hangar until its new main facility on the north ramp was finished in the 1950s. (Courtesy of Robert F. Soraparu.)

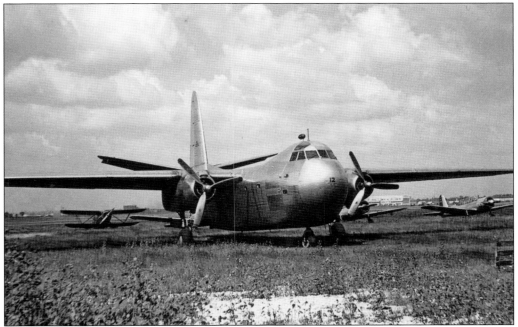

The Budd RB Conestoga, test-flown by Benny Howard, was designed by the Budd Company, which built stainless steel railroad cars. The Conestoga was designed as a military cargo ship; this particular aircraft was owned by Preston Tucker, who flew the country from Muni with a Tucker automobile in the cargo hold. (Courtesy of Robert Jesko.)

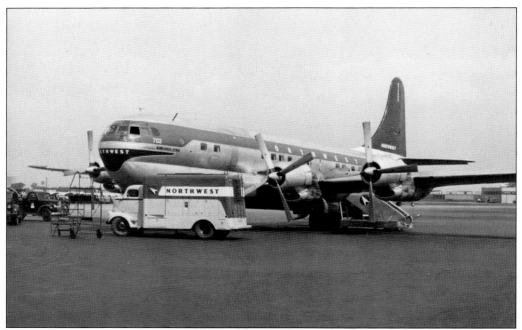

The double-deck, pressurized Boeing 377 Stratocruiser was the 747 of its day. The upper deck seated between 55 and 100 passengers, and the lower deck served as a bar and lounge. This Northwest Airlines Stratocruiser was a common sight at Midway until late 1960, when it was phased out of service. (Courtesy of Robert Jesko.)

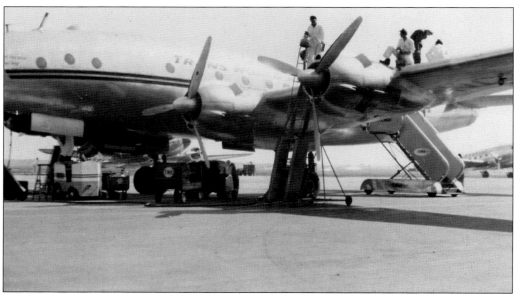

TWA Constellation N86503, Fleet No. 503, *Star of the Nile Sky Chief*, was one of the original 20 aircraft ordered by TWA and received after the war ended. Here, the crew readies it for another flight in the late 1940s. (Courtesy of William C. Aitken.)

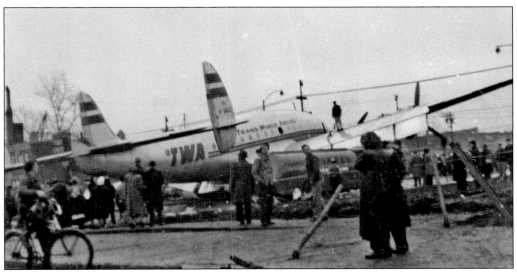

Everyone was fortunate aboard TWA Flight 154, despite the grim-looking situation in this photograph. On Sunday, December 18, 1949, a TWA 049 Constellation, N86501, *Star of the Persian Gulf*, was inbound from the northwest, landing on Runway 13R. The surface was wet, and Capt. Stanley M. "Toots" Kasper had been in the air for a long time. The airport was "IFR," or instrument meteorological conditions, but the flight was cleared to land. (Courtesy of William C. Aitken.)

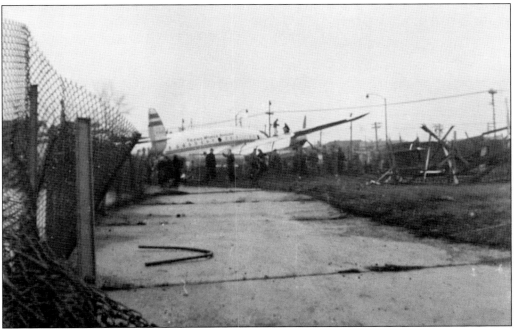

After the first attempt, Kasper declared a missed approach, going around. On the second attempt, the Connie landed 3,200 feet down the runway and began to hydroplane. The 049's brakes were not adequate to stop the airliner, and the plane did not have reverse-pitch propellers to aid in braking. Out of runway, NC86501 hit the concrete runway marker, plowed through the cyclone fence, and hit a decorative stone pillar, causing extensive damage to the aircraft. (Courtesy of William C. Aitken.)

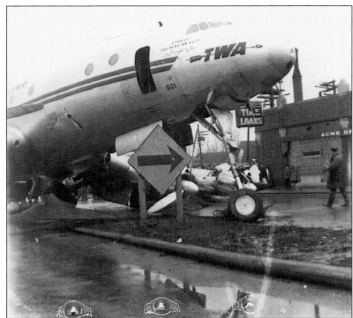

The left wing was nearly torn off as the aircraft continued into the intersection of Sixty-third Street and Cicero Avenue; although there was substantial damage, no one was injured. The aircraft was repaired and flew again. (Courtesy of William C. Aitken.)

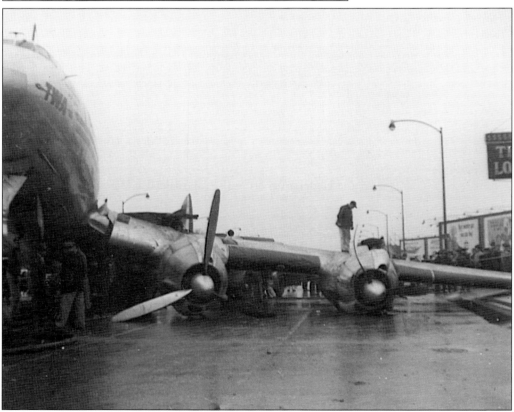

The fortunate TWA mechanic assigned the task of getting a tug and pulling all that torn-up cyclone fence back onto airport property was Jack Dusak. Jack "borrowed" the tug from American Airlines to do the job. (Courtesy of William C. Aitken.)

Seven

PROSPERITY AND THE FABULOUS FIFTIES

Pierce O'Carroll had gone to Washington to lobby on behalf of the non-scheduled, or "non-sked" air carriers. The airlines enjoyed a land office business at Midway, while the non-skeds were denied the right to compete. O'Carroll had purchased DC-3 and C-46 transports for his anticipated passengers and went so far as to write Pres. Harry S. Truman about the matter but never received a reply. O'Carroll eventually gave up the fight in 1951.

Robert F. "Bob" Zilinsky was every bit as caught up in the mystique of the air as the earliest aviators. He reminisced, "We used to ride our bikes to Muni, Harlem, and Stinson [Airports]. Everything was all open then around Municipal . . . all the way down Cicero to Archer Avenue."

Zilinsky began flying lessons at Harlem Airport in 1946 and soloed at Hinsdale in 1951. Flying was not cheap, but there were plenty of airfields, and he was resourceful. In 1951, after four years in the Air Force, he joined American Airlines as a senior mechanic, and in 1956, he became a flight engineer, flying DC-6s out of Midway. He would ultimately fly DC-10s/MD-11s out of O'Hare Airport as a first officer.

Wallace D. "Dip" Davis was a mechanic at Northwest Airlines at Midway from 1950 through 1952. Having come off the line that built Lockheed P-38s, Davis was schooled in both piston and turbine technology. Straight out of high school, he traveled to California and worked for Lockheed. During World War II, he served in the Army Air Corps as a crew chief on B-24s and B-29s and was also a maintenance instructor. Immediately following World War II, he acquired his A&E (mechanic) certificate and a private pilot license. He had already become an aviation legend when he was recruited by Northwest to care for its fleet at Midway.

Davis recalls, "We had DC-4s, Martin 2-0-2s and the [Boeing B-377] Stratocruiser. While I was at Northwest, they grounded the Martins when the pilots refused to fly them—after we lost five of them [planes and pilots]. So we leased out our remaining Martins to Trans-Ocean Airways and they flew them between the Left Coast and Hawaii. Then we bought back a few of the DC-3s we used to fly; we ran them back through the factory and they wound up installing a really nice cabin configuration, along with Janitrol heaters that were being installed in the DC-4s. Those were the warmest DC-3s in the world! The old heaters were steam boiler affairs, real nightmares

and not too efficient. In the bitter cold, you couldn't get outside fast enough to drain the water out of the heater before it would freeze."

At the age of 22, Charles "Bud" Cushing was one of the first nonmilitary pilots hired by TWA. He learned to fly while attending the University of New Mexico and later served in the Korean War. Although trained as a civilian instructor, he instructed military pilots during his tour of duty. He has since flown all over the world, including an 18-month stint training Saudi pilots to fly L-1011s, plus another 18 months in the US with full rein of his own fully staffed and viable airline operation, courtesy of his employer.

Cushing's Midway career began in DC-3s in 1952. Soon he was copiloting 049 Constellations and Martin 4-0-4s, and he retired as a captain flying 747s. As a TWA pilot, he had the opportunity to move through all the Constellation series and said of them, "The small Connies [049s] flew themselves off the ground. The later ones, the Super-Gs, needed the pilots to rotate, which required some time getting used to."

Since the early 1920s, the power plant of choice for US transports had been the radial engine. The medium-range and long-range transports of the 1940s and 1950s often featured Pratt & Whitney R-2800s and the four-row, 28-cylinder R-4360. The zenith of piston engine technology was reached in the 1950s with the twin row, 18-cylinder Wright R-3350 Turbo-Compound 18, which powered Super Constellations, DC-7s, and Starliners. Jack Dusak remembers, "Those TC-18s ran well and they were powerful—but they constantly blew oil seals and were a bear for maintenance if you mistreated them." Bill Aitken added, "The oil companies were constantly sending us secret blends of aviation fuel to see how they affected power but kept detonation down and cylinders cooler. We had no idea how a certain fuel blend would work; it definitely wasn't the same stuff each time we flew." However, all the Midway visitor or passenger knew was the cacophonous song of thrumming, blatting, roaring radials on the ramps—it was the Midway symphony.

Significant events occurred in 1955. For 29 years, the Nathan Hale School, at the southwestern end of the square mile, had seen the airport grow from a detached but busy airfield to a teeming place so noisy and intrusive that the building shook whenever aircraft took off and landed nearby. The school was flanked by Runways 4L and 4R, only yards from the schoolyard, and parents became increasingly frightened by the prospect of an accident occurring near the school. Bud Cushing recalled two specific chimney-strike incidents involving aircraft; of course, others maintain that there never was a strike. While it is true that airplanes on final over the school could conceivably be only a few yards from the chimney, the two adjacent runways were closed to traffic during school hours.

Nevertheless, pursuant to the impassioned pleas of concerned parents, a new Hale School was built west of the airport, and the old school closed on Tuesday, November 22, 1955, and was later demolished.

Earlier that year, Chicago O'Hare International Airport officially opened for business. Certification of the game-changing Boeing 707 jetliner came in 1957, with the first flights commencing the following year. America's Jet Age was on the horizon, and city leaders wanted to be ready. In 1956, the airlines began planning for the day when all airline operations would shift to ORD, the identifier for Orchard Place—the field's location combined with Douglas, the field's actual name. From that time on, Chicago's focus on Midway was for a smooth operation and a seamless, gradual transferal of traffic to the new, larger airport.

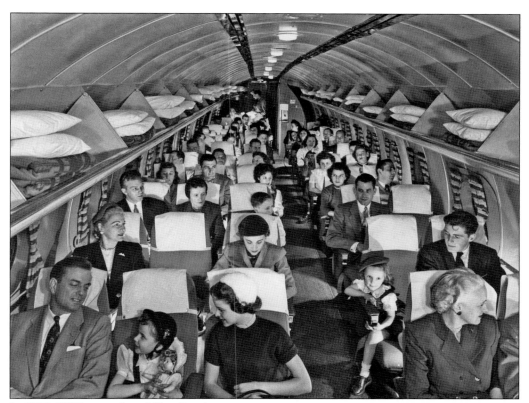

In 1950, TWA introduced Sky Coach service, a cost-effective alternative to high-priced air travel. The interiors of 049 Connies were specially refitted with color-coordinated decor, and meals were made available as options on the multistop cross-country flights. (TWA photograph, courtesy of Jon Proctor.)

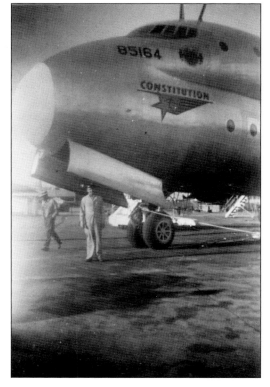

Bill Aitken poses at the nose of Lockheed Constitution No. 85164. The 60-foot-tall aircraft with a 189-foot wingspan was developed for the Navy during World War II and first flew in 1946. It included a double-deck pressurized fuselage and four Pratt & Whitney R-4360 power plants. In the early 1950s, this ship made a Navy recruiting tour of 19 cities. A total of more than 500,000 people toured the aircraft's interior. (Courtesy of William C. Aitken.)

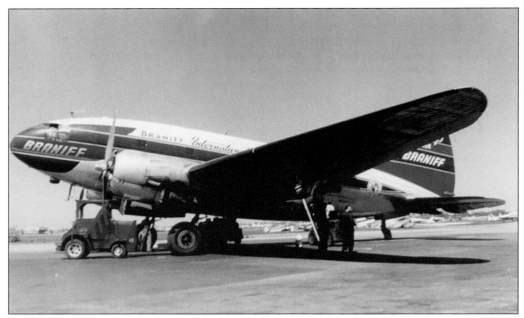

After the war, ex-military Curtiss C-46 Commandos flooded the civilian aircraft market. Many were converted to passenger configuration, while others were used as freighters. This Braniff C-46 boards passengers in the early 1950s. (Photograph by Charles Feigel, courtesy of Robert Jesko.)

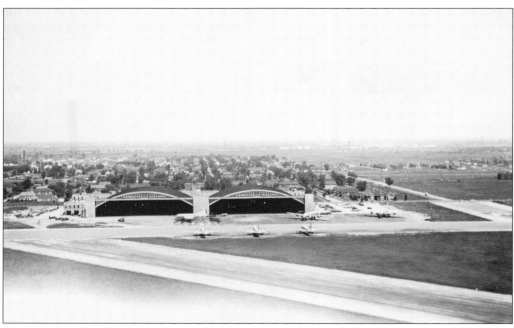

Photographer Bob Proctor captured the American Airlines complex on the north ramp in this 1950s aerial shot. (Courtesy of Jon Proctor.)

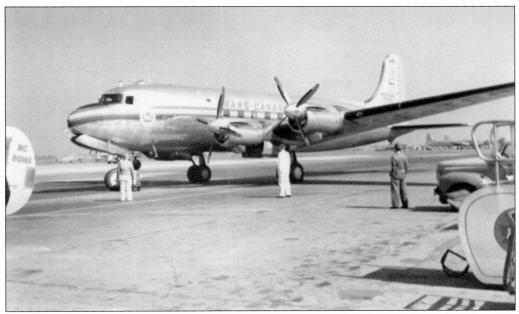

The Canadair North Star was a 1940s Canadian development of the Douglas C-54/DC-4 that used Rolls-Royce Merlin engines to achieve a 35-mile-per-hour-faster cruise than the radial-engine C-54s/DC-4s. Trans-Canada Airlines made extensive use of the versatile aircraft. (Courtesy of William C. Aitken.)

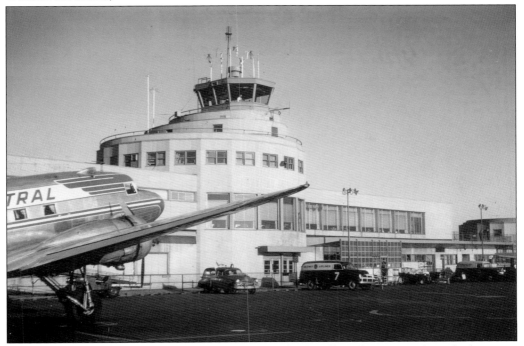

The terminal had a series of observation decks atop the first floor that spanned nearly the entire length of the complex. From them, visitors could enjoy the amazing air and ground show. Because the airport spanned only one square mile, all of its exposed operations were viewable. (Photograph by Charles Feigel, courtesy of Robert Jesko.)

A view from the observation deck toward the southeast overlooks a Wisconsin Central DC-3 and Midway Cessna 195A in the morning sun. (Photograph by Bob Proctor, courtesy of Jon Proctor.)

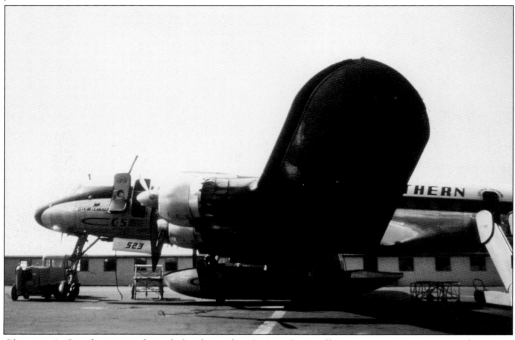

Chicago & Southern purchased the first of its L-649 Constellations in 1950, operating between Chicago and US points south, plus international points such as Caracas, Venezuela. This 1953 photograph of N86523, *City of Caracas*, shows its deployed Speedpak ready to take on luggage. In 1953, C&S merged with Delta Airlines. (Courtesy of Robert F. Soraparu.)

On March 3, 1953, an Eastern Airlines L-1049 Constellation, N6214C, experienced a landing-gear collapse on Runway 13R/31L upon landing. The aircraft skidded off-runway to the southwest, toward Hale School, stopping short of the building. Here, TWA personnel assist in moving the aircraft as the beleaguered pilot looks on. (Courtesy of John and Robert Dusak.)

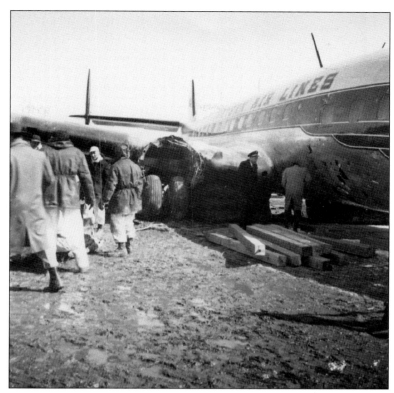

Nathan Hale Elementary School coexisted with the airport from 1926 until 1955, when constant aircraft noise, vibrations, and proximity to the runways became unavoidable issues with parents and school officials. In 1955, the school and building were closed, and the students were transferred to a new Hale School built west of the airport. (Courtesy of Patrick Bukiri.)

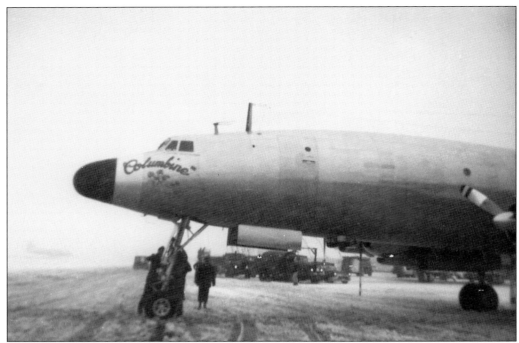

Col. William G. Draper, the pilot for Pres. Dwight D. Eisenhower, does a preflight walk-around on VC-121E *Columbine III*, a military Super Constellation used as President Eisenhower's Air Force One, at the TWA north ramp complex in 1955. (Courtesy of William C. Aitken.)

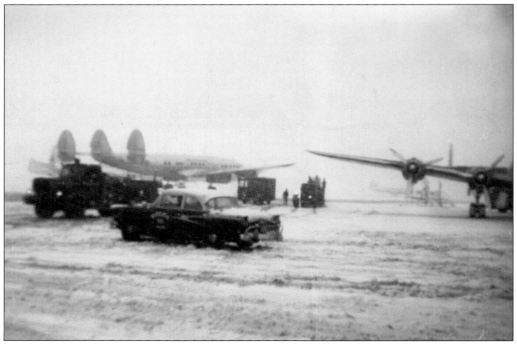

As this photograph was taken, a snow squall was moving through the area, but the takeoff was not impeded, nor was flight safety compromised. In this shot, *Columbine III* is ready to taxi to the runway for its flight back to Washington. (Courtesy of William C. Aitken.)

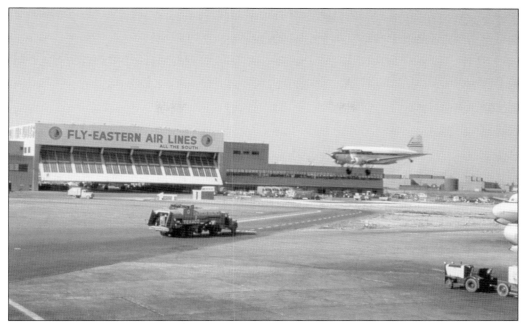

A Delta Airlines DC-3 flares for landing on Runway 22L in the mid-1950s. (Courtesy of Robert Jesko.)

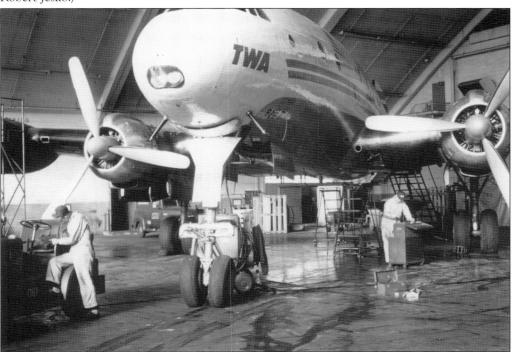

TWA mechanics work on L-749A, N86535, Fleet No. 828, *Star of Corsica*, in the north ramp maintenance hangar. In the 1940s and 1950s, TWA captains trusted the mechanics implicitly, flying confidently on the advice and repairs of the latter. "Toots" Kasper relied on Jack Dusak regarding a particular hydraulic leak issue, stating, "If Jack says it's okay, it's okay." (Courtesy of John and Robert Dusak.)

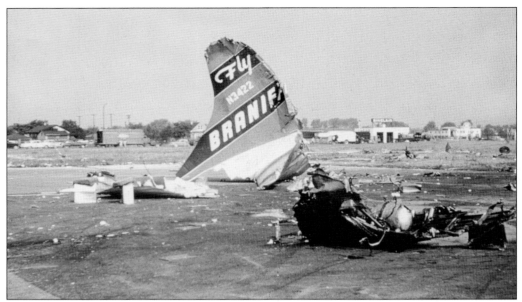

At 6:30 a.m. on July 17, 1955, N3422, a Braniff Convair 340 inbound from Kansas City carrying 43 persons, was on final instrument approach for fog-shrouded Runway 13R when the pilot became disoriented. The aircraft descended too low, striking a 15-foot-high gas station sign at Fifty-fifth Street and Central Avenue. Debris hit a car in the intersection, throwing its passenger into the street. The airliner then hit Fifty-fifth Street, bounced, and tore through the airport fence, coming down on the right wing. Fuel exploded, and the fuselage shed the tail section, spun wildly to the right, and stopped, inverted on the west taxiway. A total of 22 people were killed, and none of the survivors were uninjured. (Courtesy of William C. Aitken.)

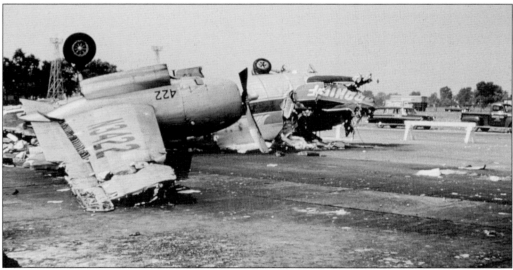

That morning, Bob Zilinsky was working in the American Airlines hangar. When he walked outside, he remembers, "I saw the airplane sliding down the taxiway. I ran over and people were pouring through the hole in the fence, taking purses and wallets. One guy was taking pictures and I said, 'Hey, you can't do that!' He turned to me and said, 'I was just on that airplane, sitting in that seat right there!' And he pointed to a seat sitting out on the tarmac by itself, away from the fuselage." (Courtesy of William C. Aitken.)

This Braniff Convair 340, identical to the one that crashed on approach to Midway on July 17, 1955, taxis in the rain. The N3422 crash received widespread international media attention. (Courtesy of Christopher Lynch.)

In 1955, Airport Surveillance Radar (ASR) installations were commissioned at Midway's four quadrants. This facility was southwest of the airport. Controllers often assisted pilots on instrument approaches by conducting Ground Controlled Approaches (GCA), later known as ASR approaches. (Courtesy of Patrick Bukiri.)

A serendipitous encounter between a Midway sailor and the iconic Marilyn Monroe at the Cloud Room resulted in this happy moment in 1955. (Courtesy of William Poturica.)

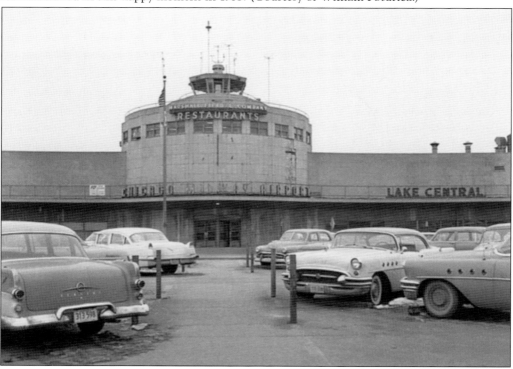

This photograph, taken no earlier than 1955 from Midway's parking lot, shows the north terminal entrance, advertising two Marshall Field restaurants: the Cloud Room and the Blue and Gold Café. (Author photograph.)

Eight

A WORLD CAPTIVATED
BY FLYING

Capt. Elroy "Buck" Hilbert was one of the regulars at Midway. He recalled, "My days with Midway were mostly with United Airlines. I did fly in there a few times back in the late-forties when a Piper PA-12 was the biggest aircraft I had available. Later on, I flew DC-3s, -6s, -7s and Viscounts—as a co-pilot on the -6s and -7s, and on the Viscounts as a Captain." As to the degree of skill required to take aircraft into Midway, Buck even flew a Douglas DC-8—one of the big jets—into and out of there in the mid-1960s.

TWA, United, American, and Pan Am were in competition for transatlantic passengers and offered the best comfort, luxury, and cuisine imaginable in air travel. In 1950, TWA also introduced Sky Coach, on one end of the affordability spectrum, which contrasted with its Sleeper Connie service, which began in 1948 and was the most luxurious way to fly. Travelers could take the train, but air travel was now faster, more comfortable, safer, and exciting. Additionally, increasing numbers were being introduced to it from Midway Airport.

TWA's giant north ramp complex was completed in 1955. Dan McIntyre, with Midway station operations, recalled, "One morning, a WWII B-25 bomber, painted in TWA red and white livery, taxied into the west bay of the hangar . . . this would have been a major no-no, but it was there to pick up someone named Hughes."

However, the thrill of flying would end for Monarch's Scotty O'Carroll. The man so involved in the fabric of the airport suffered a stroke in 1957. He had hosted the Muni-based film shoot of Jimmy Stewart's 1948 aviation movie *You Gotta Stay Happy*. He had welcomed Jimmy Doolittle, Charles Lindbergh, and Orville Wright. He had flown Hollywood greats such as Orson Welles and Ingrid Bergman; now he was grounded.

Hollywood's brightest stars all landed at Midway, and in the summer of 1958, Cary Grant and Leo G. Carroll were on location to film a scene for Alfred Hitchcock's timeless *North by Northwest*.

The Air Age was truly enchanting. Movies like *Casablanca*, *Captains of the Clouds*, and *The High and the Mighty* were favorites of all ages. Wide-eyed boys watched *The Whirlybirds*, *Sky King*, and *Steve Canyon* on television every week. They sat enthralled before their radios, listening to *Captain Midnight* and *Uncle Ned's Squadron*, featuring guests such as Robert Jesko, who, as a young adult just eight years later, flew off with Braniff International from Midway.

Flying-related movies and TV shows of that era depicted heroic male and female pilots living lives of great adventure, and all of America loved aviation. Private flying was at an all-time high, as the dream of flight became a reality for Americans of all ages and walks of life.

The excitement of watching aircraft operations up close and personal was an everyday part of Midway life, especially on summer days and evenings in the 1950s, when it was the world's busiest airport. For kids of all ages, there was something almost mesmerizing about the sights and sounds of this portal to far-off places that overloaded the senses. Commerce in motion, especially with wings, was both important and mysterious. And the visitor got to see it all from the best vantage point on the airport: the observation decks above the terminal. For only a dime, telescopes mounted on each deck allowed viewers to see airplanes and operations a mile or more away. Constantly, all around the visitors and ground personnel, from day into night, massive airliners purred, rumbled, and roared off into the sky, with the aroma of 115/145 Octane avgas and hot oil hanging in the air. The sound was likened to Chicagoans running every one of their electric fans at high speed—that was Midway in the 1950s.

Daniel F. McIntyre began working for TWA in Ground Service in 1952 and did not retire until 40 years later. In the 1950s and early 1960s, passengers boarded flights by exiting the terminal gate, walking out onto the tarmac to their plane, and ascending the stairs of an outside loading ramp to be greeted by a flight hostess. McIntyre recalls, "When you worked on the ramp at the airport during the 1950s and 1960s, you saw a lot of things: people hugging and kissing. People crying. Family reunions. Kids going off to war."

In 1958, Midway hosted 20 major airlines. Mike Berry was then the airport manager, and the airport had the best instrument approaches, lighting, and navigational aids for all-weather flying.

United and Capital began using O'Hare as a reliever for many of their scheduled flights, and many airlines were also using ORD as an international terminus. A TWA 1649A Jetstream Starliner, nonstop from Paris, was the first international flight to land at O'Hare's International Terminal on August 8, 1958. The pilot was Harold Neumann—the same Harold Neumann who had raced against, and then with, Benny Howard and *Mr. Mulligan* in the 1935 Thompson Trophy Race. Two years later, all the internationals had transferred to the new "jet age" Chicago airport.

Late in the 1950s, a crash occurred just outside Midway that affected an entire TWA family and its neighborhood. At 5:31 a.m. on November 24, 1959, a TWA 1049H Constellation, N102R, took off from Runway 31L. On climb-out, the crew received a fire warning from the number-two engine and promptly shut it down. Under a 500-foot ceiling, the pilot circled to land, initiating a 45-degree left bank, which caused an excessive rate of sink. Despite raising the nose to climb altitude, with the wings nearly level, the plane was already at the treetops but continued to sink. The aircraft settled into the neighborhood at Sixty-fourth Street and Kilpatrick Avenue, just south of the field, and exploded, killing the crew of three as well as eight people on the ground. N102R was carrying a jet engine and other freight. Jack Dusak, who was working that morning, was called to the scene. He remarked, "When I arrived there, the first thing I saw was that jet engine sitting out in someone's front yard." One of Dusak's close TWA colleagues, George Mehalov, had been in his home, shaving, when the crash occurred. Mehalov was blown out of the building, and his wife and 18-year-old son were killed. It was two days before Thanksgiving.

Midway ended 1959 breaking all previous records, with 10,040,353 passengers and 431,400 operations. It would not see numbers comparable to those until 40 years later.

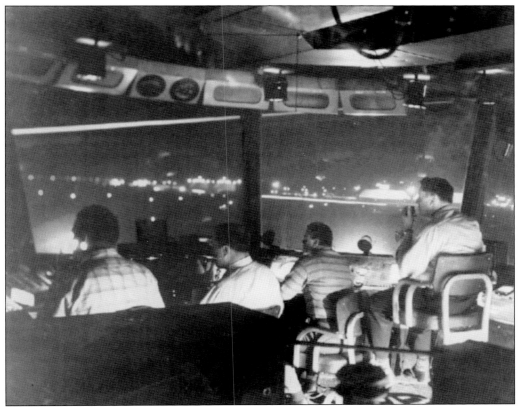

In its Air Age heyday as the "World's Busiest Airport," Midway took on a different mystique at night. In this 1956 photograph taken from inside the control tower over the north terminal, "ground" and "local" direct a myriad of vehicles in the air and on the ground. (Courtesy of John Chuckman.)

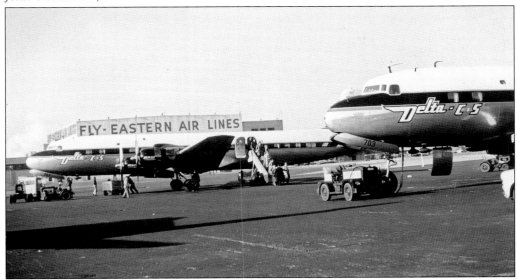

Two Delta-C&S DC-7s await their passengers at the Delta gate in the mid-1950s. (Courtesy of Robert Jesko.)

A member of the TWA grounds crew transports goods via motorboat on the north ramp in 1957. Over 24 hours, beginning on Friday, July 12, 1957, a total of 6.24 inches of rain fell in the Chicago area, flooding the city and the suburbs. Midway's power and communications went out, and more than two feet of water covered runways. Six inches of water flooded the packed terminal, stranding thousands of passengers. (Courtesy of William C. Aitken.)

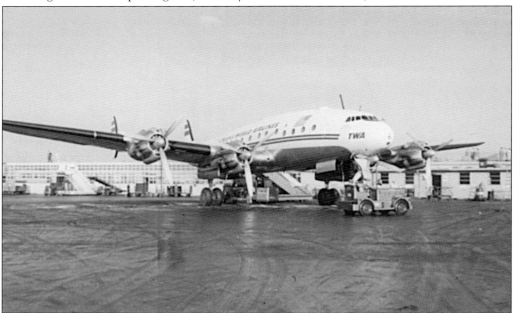

TWA 049 Constellation N86511, Fleet No. 555, sits regally at the TWA gate in 1957. Unfortunately, this aircraft and all 78 people onboard met tragedy on September 1, 1961, as the "Triple Nickel" lost a bolt in its tail's hydraulic boost package, causing an accelerated stall. With its tail section disintegrating, the aircraft plunged into a Clarendon Hills cornfield and exploded five minutes after takeoff. (Courtesy of Charles Feigel.)

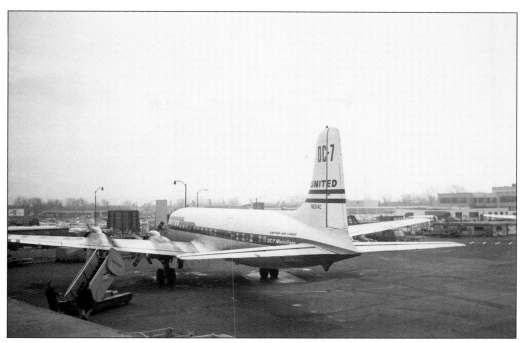

Jon Proctor photographed United DC-7 N6314C, *Mainliner Honolulu,* from the observation deck on March 9, 1957. (Courtesy of Jon Proctor.)

A passenger in a taxiing aircraft captured this line of DC-7s awaiting clearance for takeoff from the tower. (Courtesy of Robert F. Soraparu.)

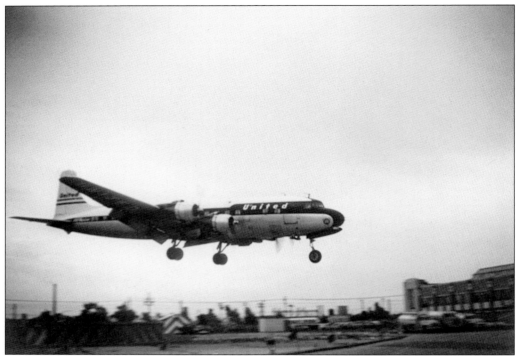

Photographs of piston airliners arriving at Midway are favorites. This United DC-6 is on final approach for Runway 31L. (Courtesy of Christopher Lynch.)

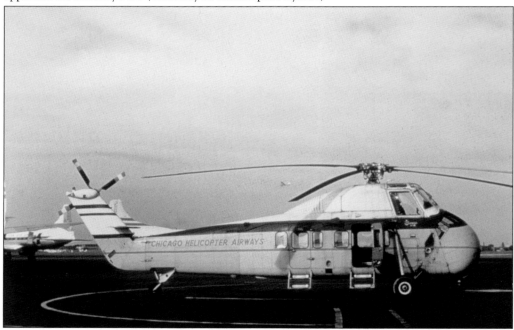

In 1956, Chicago Helicopter Airways (CHA) began service between Midway, O'Hare, and Meigs Fields, flying Sikorsky S-55s. It was successful from the start, flying 55,000 passengers its first full year. The airline then purchased three new S-58s, and ridership continued to climb. (Courtesy of Robert Jesko.)

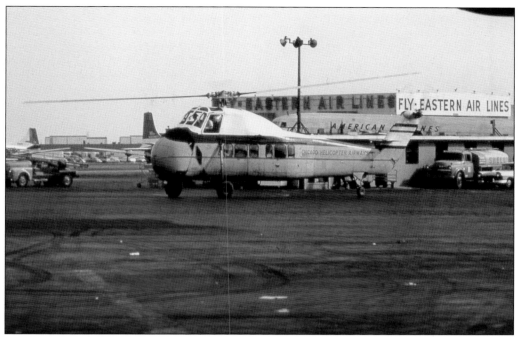

By 1960, CHA had transported 309,000 passengers, operating an incredible 158 daily flights in eight aircraft despite the July 27, 1960, crash of S-58C N879, which claimed 13 lives. (Courtesy of Robert Jesko.)

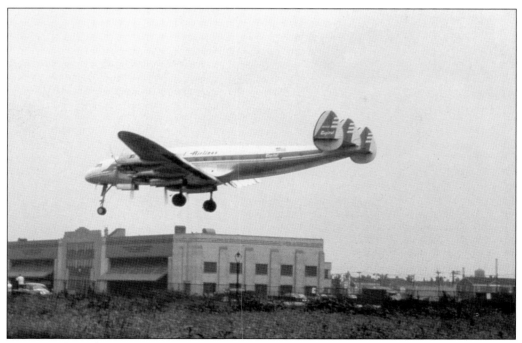

A Capital Airlines 049 Connie flies final approach for Runway 4R. (Courtesy of Charles Feigel.)

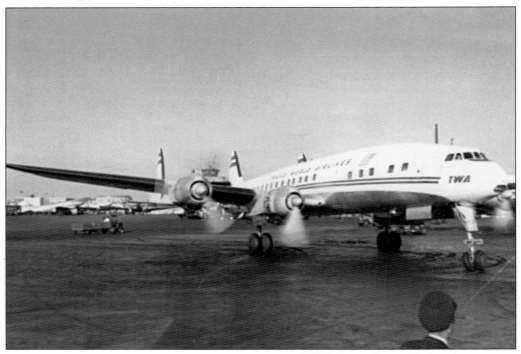

TWA Super Constellations were magnificent-looking and fast. Sadly, this one, N6907C, *Star of Sicily*, was hit by a United DC-8 jetliner over Staten Island, New York, on December 16, 1960. The crash killed all aboard both aircraft. (Courtesy of Charles Feigel.)

Capt. Jack Schnaubelt of TWA began flying in 1927, the "year of Lindbergh." He barnstormed over the next 12 years and recalls, "During the Depression, when money ran low, the wing of my airplane was the roof over my head—but it was great fun." Schnaubelt joined TWA in 1939 and flew for the next 30 years before retiring in 1969. His wife, Loretta, was also an accomplished pilot, having soloed in 1933. (Courtesy of William C. Aitken.)

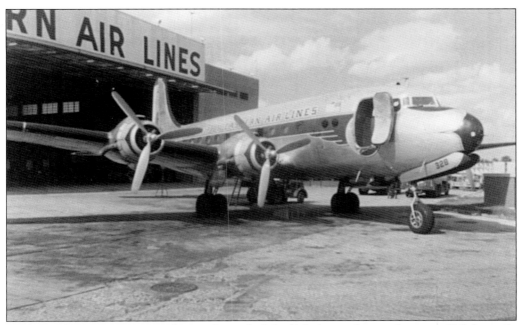

Realizing the greater range, utility, and speed of the DC-4 over the revolutionary DC-3, nearly every airline went with DC-4s after World War II. This Eastern DC-4B began life as a C-54, S/N 42-7344. The photograph was taken in May 1958. (Courtesy of Charles Feigel.)

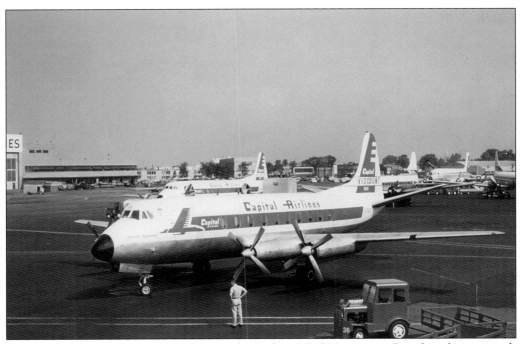

In the late 1950s, Midway became host to the Vickers V745 Viscount, a British turboprop, with Capital Airlines flying most of them. This photograph was taken on June 6, 1959. (Courtesy of Jon Proctor.)

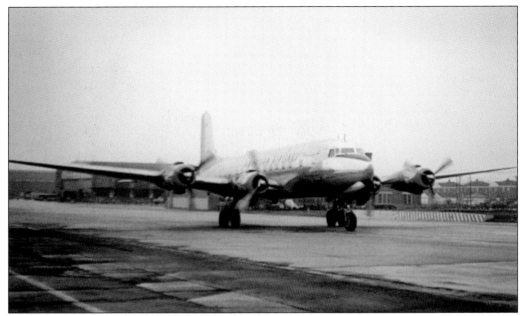

An American Airlines DC-6 taxis down the east ramp for run-up and takeoff on Runway 31L. Bob Zilinsky flew these year-round until the move to O'Hare in 1962. (Courtesy of Christopher Lynch.)

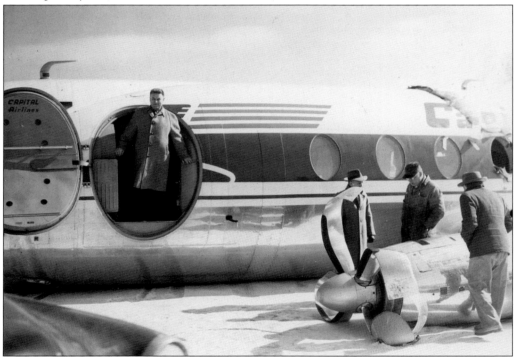

Scotty O'Carroll stands in the doorway of Capital V745 N7404 after it crash-landed at Midway on February 20, 1956. O'Carroll had seen his share of pranged airplanes and was likely relieved. He seems to be saying, "Darned glad it's not mine this time!" None of the 41 people aboard were injured. (Courtesy of the O'Carroll family collection.)

Learstar N200L rests on the south ramp in April 1958. Inventor and aviation businessman William P. "Bill" Lear began converting Lockheed Lodestars in a moderately successful move to update and remarket this latter generation of the first L-10 Electras. (Courtesy of Robert Jesko.)

A common but exciting sight in the 1950s was an American DC-6 coming in for landing on Runway 22L over Fifty-fifth Street near Cicero Avenue. (Courtesy of Robert F. Soraparu.)

This sight was familiar to every air-minded consumer in the 1950s: the tail of a TWA Super-G Constellation. It was advertised on billboards, on television, in magazines, and even atop an eight-story building in Chicago's Loop, where a giant metal model of one was mounted on a steel framework above a huge sign. (Courtesy of Charles Feigel.)

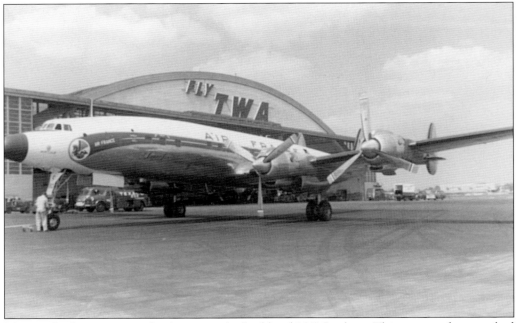

The zenith of piston-powered airliners was the Lockheed 1649 Starliner. This one was photographed at the "World's Busiest Airport" in July 1958. (Courtesy of Charles Feigel.)

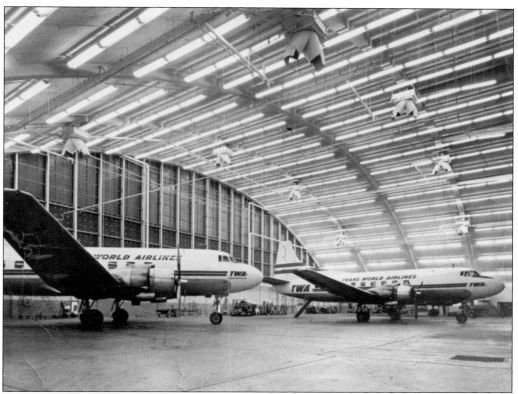

TWA's north ramp facility, completed in 1955, was an immense improvement over the airline's old south ramp hangar. Here, two Martins prepare for flight. (Courtesy of John and Robert Dusak.)

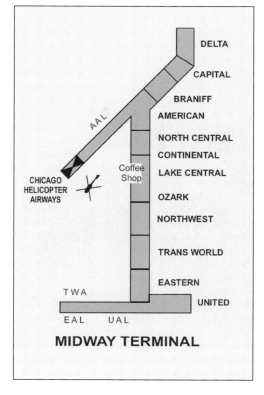

DELTA

CAPITAL

BRANIFF

AMERICAN

AAL

NORTH CENTRAL

CONTINENTAL

Coffee
Shop

LAKE CENTRAL

CHICAGO
HELICOPTER
AIRWAYS

OZARK

NORTHWEST

TRANS WORLD

EASTERN

TWA

UNITED

EAL UAL

MIDWAY TERMINAL

This diagram illustrates the main gates at the north terminal and the domestic airlines serving Midway by 1958. (Author photograph.)

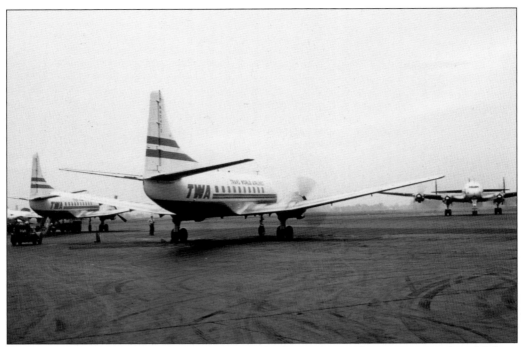

At the north ramp, two TWA Martin 4-0-4s and a Connie await clearance to taxi from Midway ground control in 1959. (Courtesy of John and Robert Dusak.)

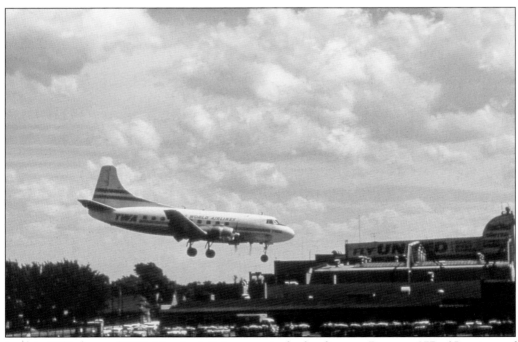

In this 1959 shot, a TWA Martin 4-0-4 comes in for landing on Runway 27R. (Courtesy of Charles Feigel.)

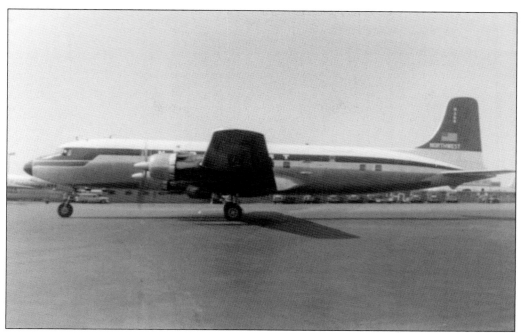

In the 1950s, Northwest Airlines flew DC-6s on its transcontinental and Hawaii routes. An NWA DC-6 was also one of the stars of the movie *North by Northwest*, which was filmed on location at Midway in 1958. (Courtesy of Charles Feigel.)

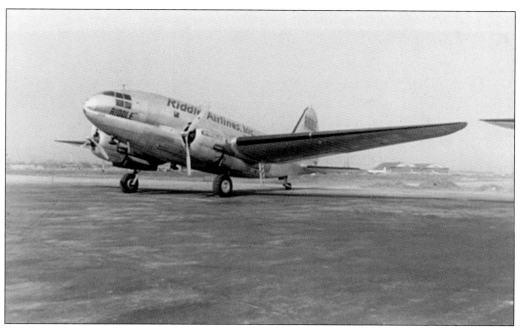

Riddle Airlines, a Miami-based freight carrier founded in 1945, made use of surplus C-46 aircraft. This C-46 is parked on the west ramp across from Riddle's Midway facilities. (Photograph by Charles Feigel, courtesy of Robert Jesko.)

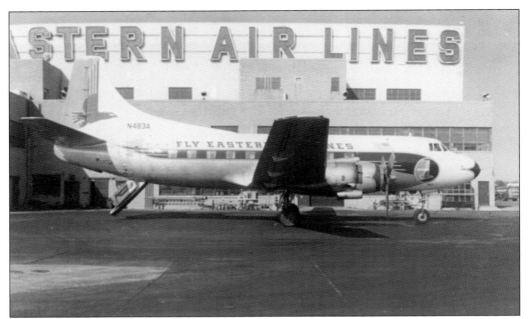

The first deliveries of Martin 4-0-4s were made in 1951 to Eastern Air Lines, which ordered 60 of them. Eastern 4-0-4s were seen all up and down the East Coast in the 1950s, and for a time, Eastern was the most profitable airline in the postwar era. (Courtesy of Charles Feigel.)

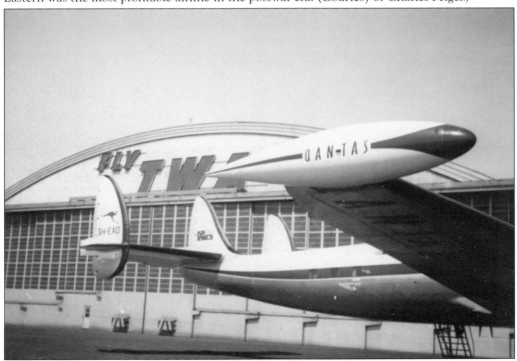

Qantas's Super-G Constellation *Southern Dawn*, VH-EAD, makes a rare appearance at Midway in 1958. It had possibly flown in from London Heathrow and needed readying for the trip back to Australia. TWA maintained all international Constellations that flew into Midway. (Courtesy of John and Robert Dusak.)

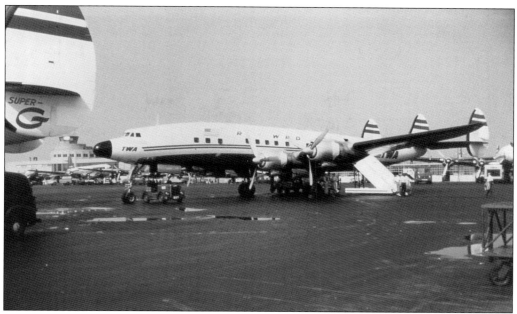

TWA's Dan McIntyre enthusiastically described flying in the 1950s: "It was an adventure to fly on our piston fleet. The flights were longer and there was more interplay between the passengers and crew. I recall one flight on a 1049 Super Connie [out of Midway] when, after lunch, the hostess set up a poker game. She used the forward cabin and they played for matchsticks. She even wore a green visor when she played. Her flying partner told me she did it on almost every trip." (Courtesy of Charles Feigel.)

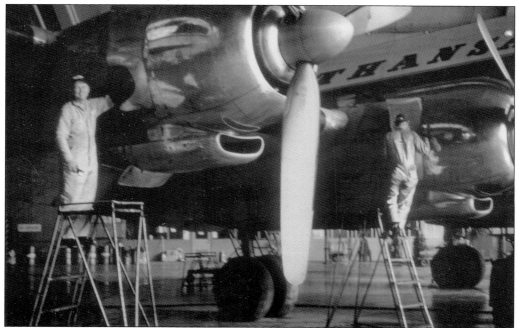

Other international visitors to Midway from Europe flew in on Deutsche Lufthansa's Super Constellations. Here, TWA mechanics check the oil seals on the power-recovery turbines of the airliner during maintenance. (Courtesy of John and Robert Dusak.)

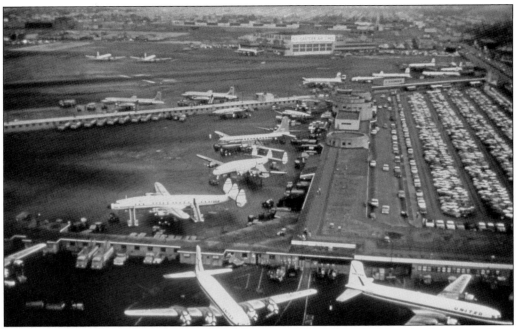

The year 1959 was Midway's busiest ever for piston traffic. This photograph, shot from above the United gates at the north terminal, shows just how heavy the airline traffic was. (Courtesy of Robert F. Soraparu.)

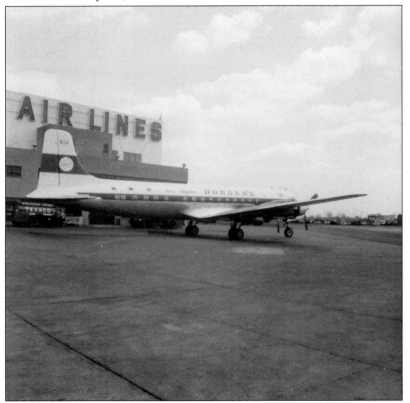

The Los Angeles Dodgers had just moved from their former Brooklyn home to the West Coast and retained two aircraft under lease from Eastern Air Lines: a Convair CV-340 and this DC-7. (Courtesy of William C. Aitken.)

Capt. Roger Don Rae stops for a photograph at TWA in the 1950s. He began an amazing career that included barnstorming, aerobatics, test flying, air racing—against Harold Neumann and Benny Howard in 1935—and parachute jumping. He joined TWA as a DC-2 copilot in 1936 and retired in 1969. (Courtesy of William C. Aitken.)

A new turboprop airliner was soon flying into Midway: the Lockheed L-188 Electra. Like the Viscount, it was designed as a bridge between piston and pure-jet technology. Both used jet engines in a free-turbine configuration, swinging four-bladed propellers. Eastern, American, Braniff, and a number of other airlines flew Electras. This Braniff L-188 is landing on Runway 27R. (Courtesy of Robert Jesko.)

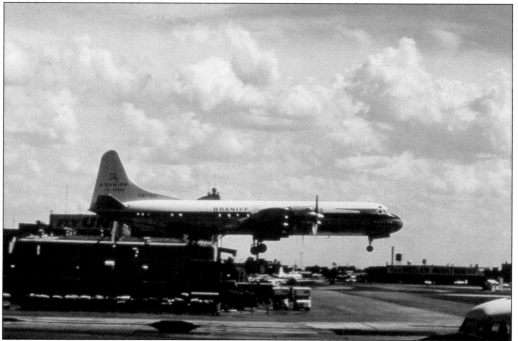

Favorite views were not restricted to the observation decks at Midway. This summertime shot was taken from a Lockheed Electra in flight about a mile east of Midway. (Courtesy of Robert F. Soraparu.)

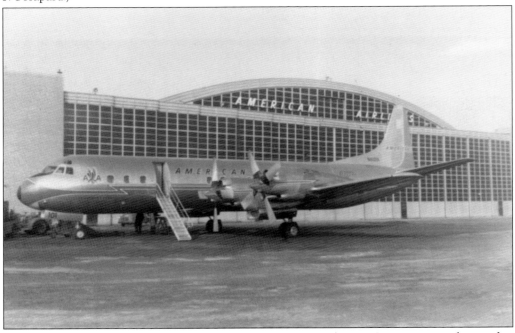

This L-188A, N6101A, crashed on February 2, 1959, in New York's East River, just nine hours after this photograph was taken. Ironically, singer Buddy Holly and three other rock 'n' roll recording artists were also killed on the same day in the crash of a Beechcraft Bonanza in a cornfield near Clear Lake, Iowa. (Courtesy of Charles Feigel.)

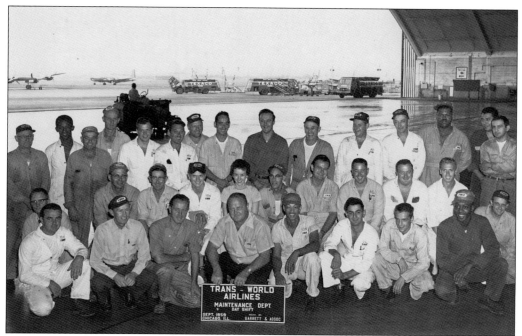

The TWA day maintenance crew poses for a group photograph in the hangar in September 1959. Standing in the center of the third row with the dark shirt on is George Mehalov, an amiable colleague who called everyone "Shorty." Mehalov suffered the loss of his family just blocks away from Midway on November 24, 1959, in the crash of TWA Flight 595. (Courtesy of William C. Aitken.)

The normally busy Eastern ticket agents enjoy a period of quiet on November 1, 1958. (Courtesy of Robert F. Soraparu.)

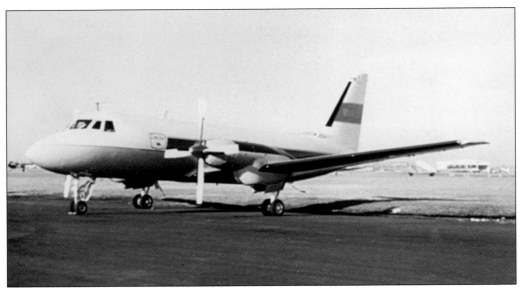

The Gulfstream 1 was Grumman Aircraft's first in a successful line of business aircraft that evolved into pure jets. The first Gulfstreams were turboprops. This photograph was taken in November 1959. (Courtesy of Charles Feigel.)

Death and destruction came to Sixty-fourth Street and Kilpatrick Avenue on November 24, 1959. TWA Flight 595, L-1049-H Constellation Freighter N102R, crashed after trying to return to Midway following an engine failure. (Courtesy of Patrick Bukiri.)

Nine

MIDWAY MEETS THE JET AGE

Midway remained exceptionally busy in 1960. TWA, American, Pan Am, and United were already flying from O'Hare in the big new jets and some piston flights. Jack Dusak and many of TWA's mechanics were transferred there. Bob Zilinsky still flew the DC-6s from Midway, but within two years, the airlines would leave. The original, scheduled transfer of operations was 1965; however, airline managers did not want to pay for facilities at two Chicago airports, and a push to complete O'Hare's terminal and airline operations much sooner took place.

In 1961, Scotty O'Carroll, on vacation in New York, died of a stroke. As the aircraft bearing his casket landed at his beloved home airport, Midway tower dimmed the runway lights in honor of the airport's Lone Eagle.

On September 1, 1961, TWA Flight 529, N86511, a 049 Sky Coach Constellation, arrived from New York on a routine multistop Boston–San Francisco run. It arrived at Midway at 1:18 a.m. and changed crews. Capt. Phil Van Reeth, who lived in Chicago, briefed Capt. James Sanders on the aircraft, Fleet No. 555 ("the Triple Nickel" in TWA parlance). Receiving clearance to the Las Vegas Airport, TWA Flight 529 lifted off from Runway 22L at 2:00 a.m. with Captain Sanders, first officer Dale Tarrant, flight engineer James Newlin, stewardesses Barbara Jane Pearson and Nanette Fidger, and 73 passengers. Fidger was engaged; this was to be her final flight before marrying and moving to Indianapolis.

Four minutes out, a nightmare scenario unfolded. A 5/16-inch-by-2-1/4-inch AN-175-21 nickel steel bolt vibrated out of its bushing in the elevator's hydraulic boost package in the parallelogram linkage, which controlled the aircraft's elevator. Without warning, the malfunctioning boost system slammed the elevator up 40 degrees, pitching the nose up and throwing the aircraft into an accelerated stall. Structural failure began, and the tail began shedding parts over Plainfield and Roger Roads as the airliner turned north and began flying down Clarendon Hills Road. One minute later, 90 degrees off course, the aircraft's right rudder and fin separated from the horizontal stabilizer, falling in an open prairie just north of Sixty-first Street in Clarendon Hills.

About 400 feet farther on, the out-of-control Connie plunged into a cornfield and exploded, killing all 78 aboard. Those who truly understood the technical aspects and mechanisms concluded that a cotter pin was left out of the bolt assembly during an inspection 10 months earlier, allowing

the nut to gradually back itself off the bolt. The bolt then slid out of its bushing on that fateful flight, throwing the aircraft into the stall that ended in disaster.

At Midway, the exodus continued. Passengers in 1961 totaled 3,565,561, roughly half the 1960 total. The 1962 passenger numbers plummeted to 659,550. A mass migration occurred on April 29, 1962, and United Airlines completed the last scheduled flight out on July 9.

Chicago mayor Richard J. Daley, an ardent supporter of Midway Airport, petitioned the Civil Aeronautics Board (CAB) to halt the exodus, to no avail. The airport maintained a smattering of flight operations, mostly freight, and Chicago Helicopter continued their service as well. Midway was now all but deserted, with 1963's passenger numbers only two-thirds of 1962's at 417,544.

Daley worked tirelessly to get traffic back to the airport. In 1964, some of the airlines, led by United, were persuaded to return with limited flights. Boeing 727s began flying that year, and the Douglas DC-9 followed in 1965. Daley promised a revitalized terminal with more gates, and the airport began a slow upward climb.

Chicago Helicopter Airways ended its S-58 service on the last day of 1965, when government subsidies ended. Many of the major airlines came back in 1967 and 1968, after the terminal was redesigned and the gates doubled. CHA resumed service on May 20, 1969, with Bell JetRangers and continued service until July 15, 1975, operating 10 flights between Midway and O'Hare.

The airlines continued flying medium-range jets out of Midway until 1973—then came the Arab oil embargo, followed by nationwide price freezes. With the country in a recession complete with oil shortages, the result was a second exodus from Midway in summer 1973. However, four airlines stayed, with Delta, Northwest, Piedmont, and Southern continuing token service. Northwest left in 1975, and Delta continued on until September 1981.

General aviation kept Midway teeming with light singles, light twins, corporate jets, the occasional large piston freighter, singer Ray Charles's Viscount, TV station traffic-copters, Air National Guard choppers, and the Goodyear blimp.

Midway's commercial renaissance was a direct result of Pres. Jimmy Carter's 1978 airline deregulation, which ended the 46-year iron grip of government regulation of the airlines and air routes. Spearheading the renaissance was Midway Airlines, which commenced operations at Midway in November 1979. The marriage of airport and airline, coupled with timing and initiative, was perfect. Traffic and passenger numbers slowly climbed until the early 1990s. Midway Airlines folded in 1991; however, new carriers arrived, and numbers began to climb again. By 1998, all of Midway's previous passenger and operations numbers had been broken.

In 1982, the City of Chicago purchased Midway's square mile from the board of education, and by 1998, Midway was the fastest-growing airport in North America. In 1999, it served 13 million passengers, and in 2010, nearly 18 million.

To bring Midway into the 21st century, a new multimillion-dollar terminal complex opened in 2001. Now a glass-and-steel, state-of-the-industry air hub, Chicago Midway International Airport is a different place. Passengers wait in long lines once again, albeit with shoes removed, and then rush off to a multitude of gates in the huge, brilliantly lit terminal.

Midway certainly looks different, too, with the new terminal extending a half-mile farther east across Cicero Avenue—the old square mile was finally breached. But memories never grow old, and the Air Age Midway Airport remains powerful and vivid in even the youngest imagination. Just ask those who remember and those who dream.

One step back in memory instantly transports to the days of the mighty radials, the observation deck, and the magic of the sea of blue lights a mile long and a mile wide. Anyone who envisions or remembers can revisit that Midway any time and recall beautiful warm nights alight with giant neon airline signs as the last rays of sun paint a magnificent orange, purple, and indigo portrait of clouds and sky above the airport. Standing on the observation deck, gazing west, one can clearly see and hear the DC-6 and that Constellation as each airliner awaits release then roars skyward in a magnificent, rumbling symphony, a beautiful silhouette with engine exhausts and navigation lights blazing. What an amazing place this is.

Despite his cherubic face, TWA captain Warren G. Malvick was a real cowboy. Capt. Charles "Bud" Cushing told the story of a flight with Malvick—Cushing did the flying from the right seat while Malvick manufactured ammunition from the left seat. Once they had landed, the redoubtable Malvick began testing his ammo and his aim on two or three taxiway lights! How is that for friendly skies? (Courtesy of William C. Aitken.)

Caroline was the name of this Convair CV-240 that John F. Kennedy flew to campaign destinations during his 1960 presidential campaign. Owned by Joseph P. Kennedy, it was named after JFK's daughter. (Photograph by Charles Feigel; courtesy of Robert Jesko.)

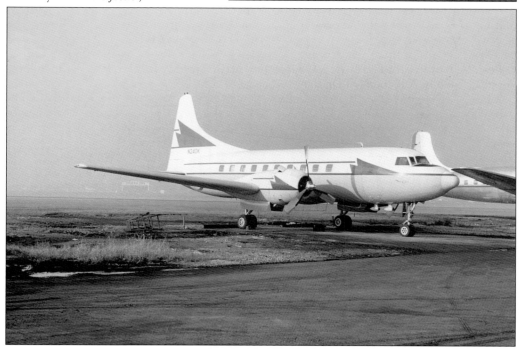

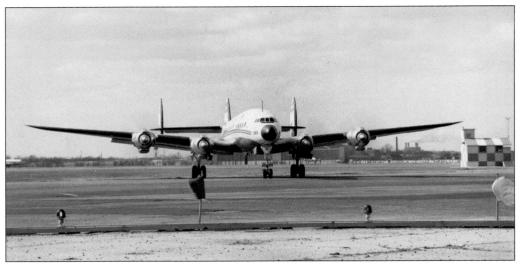

The following several pages feature a rich series of excellent photographs shot by Laird Scott on March 17 and 18, 1960, at Midway. Here, the flight crew of a TWA Super Connie performs run-up and preflight checks. (Courtesy of Laird A. Scott.)

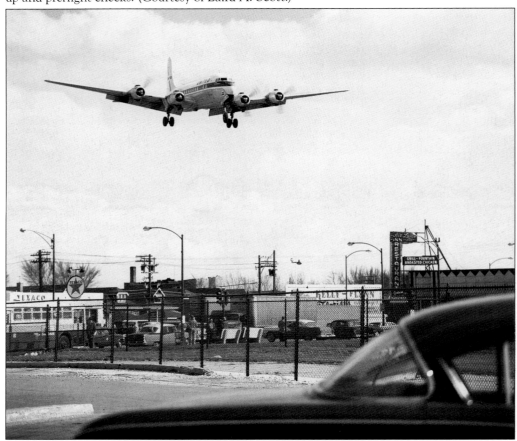

A United Airlines DC-6 is directly over Sixty-third Street and Cicero Avenue on final approach for Runway 31L. (Courtesy of Laird A. Scott.)

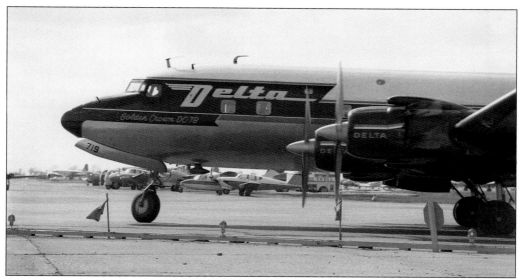

A Delta DC-7 performs its run-up prior to takeoff. The aircraft is on the west ramp, with general aviation aircraft in the background. (Courtesy of Laird A. Scott.)

The American Airlines operations tower crew overlooks the gates in this intriguing night shot. (Courtesy of Laird A. Scott.)

From the observation deck, the view is tremendous: a trio of Electras at the American gate waits to load passengers, while a small helicopter sits parked at the Chicago Helicopter Airways gate. (Courtesy of Laird A. Scott.)

A Capital Airlines 049 Connie, N2737A, waits to board at the gate. This aircraft was sold to a non-sked the following year, after United purchased Capital. It crashed on emergency approach to the Richmond, Virginia, airport, killing all 79 persons aboard. (Courtesy of Laird A. Scott.)

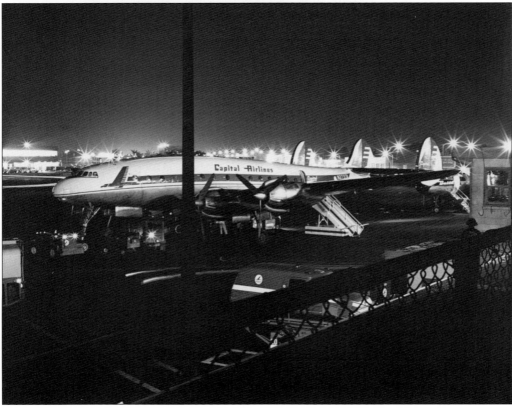

A Capital stewardess and cabin crewmember check their passenger manifest prior to departure. (Courtesy of Laird A. Scott.)

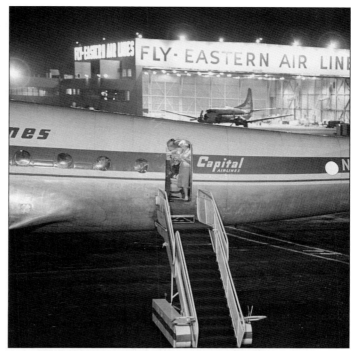

Around the corner, an Ozark Airlines Fokker Friendship (F-27) sits under the watchful eye of maintenance personnel, with an Ozark DC-3 in the background. (Courtesy of Laird A. Scott.)

This time-exposure was taken looking south from the Ozark Airlines gate. (Courtesy of Laird A. Scott.)

Midway Airport's romance and allure drew many couples—the thrill of flying blended well with the thrill of love. This Laird Scott photograph speaks more to both than words ever could. The Connie is an L-749, Fleet No. 706, N91206, *Star of Venice* (later the *Star of Illinois*). (Courtesy of Laird A. Scott.)

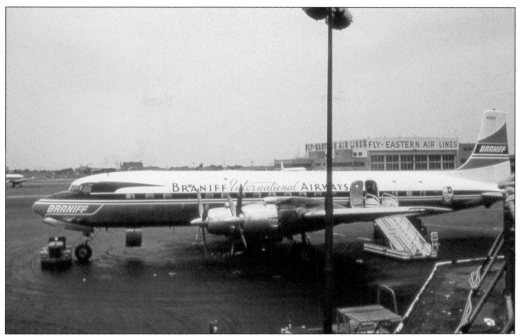

The DC-7, Super-G Constellation, and 1649 Starliner were the most advanced piston-engine airliners, exacting every last bit of horsepower from their Wright R-3350 TC-18 engines, each of which produced 3,350 horsepower. This Braniff DC-7C was the final Douglas piston variant; then came the game-changing DC-8. (Courtesy of Robert Jesko.)

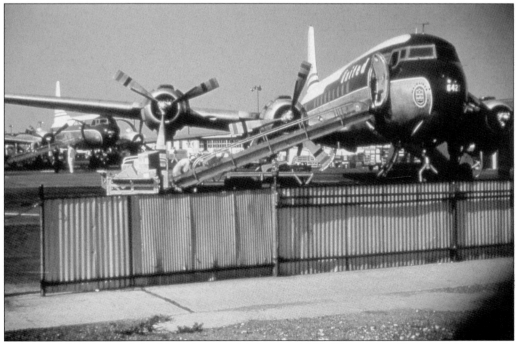

DC-6s and DC-7s crowd the United gate at Midway in 1960. (Courtesy of Robert F. Soraparu.)

During the early days of its revitalization, Midway's terminal continued to beckon visitors to the "Crossroads of the World." (Courtesy of Robert F. Soraparu.)

A Mexicana DC-6 was a common sight at Midway's international (south) terminal. (Courtesy of Robert F. Soraparu.)

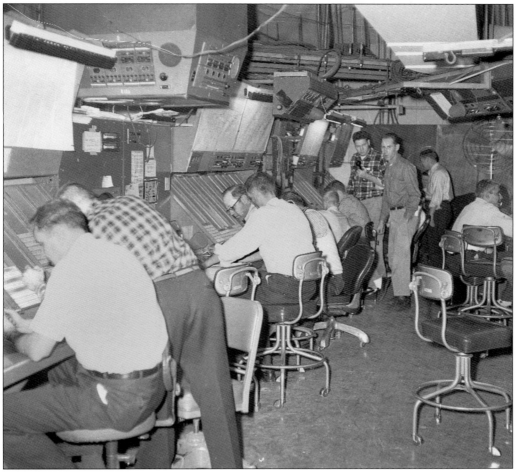

Seen here on December 20, 1960, the Chicago Air Route Traffic Control Center (ARTCC), based at Midway Airport, was still using 1950s technology. However, radar soon took over, and the ARTCC moved to Aurora, in the far west suburbs of Chicago. (Courtesy of William Poturica.)

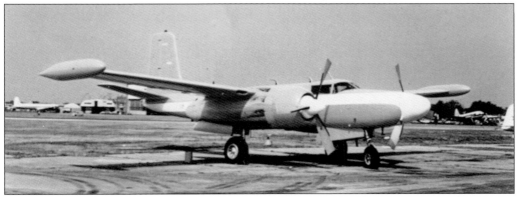

Many surplus World War II–era military aircraft became the first postwar business and corporate airplanes, as certain companies specialized in converting them into fast, modern, luxurious transportation for businesspeople. This On Mark Marketeer was a prime example. (Courtesy of Robert Jesko.)

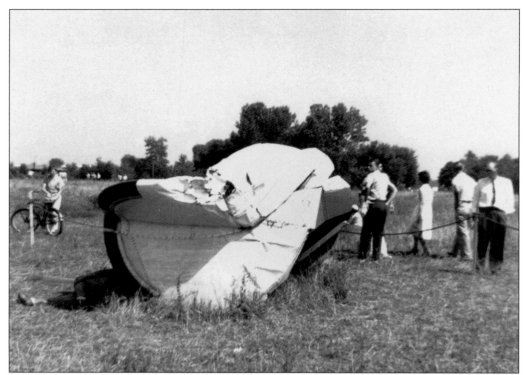

Residents congregate near the wreckage of TWA Flight 529, N86511, which lost control and crashed in a Clarendon Hills cornfield on the morning of September 1, 1961, killing all 78 people on board. (Courtesy of Elmer H. Maves.)

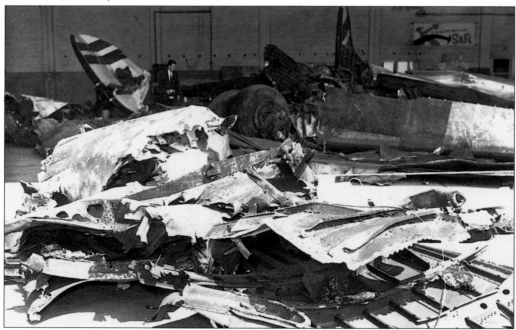

Wing, main gear, and tail section wreckage of TWA Flight 529, N86511, await examination by CAB investigators in Midway's TWA hangar in September 1961. (Courtesy of Capt. Robert Russo.)

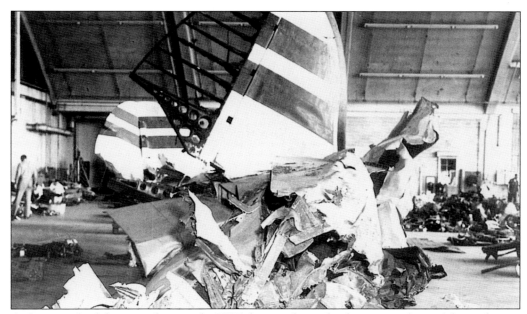

A close-up of tailplane wreckage in the TWA hangar shows the devastating force of the explosion, which occurred after the aircraft lost control and plummeted into the ground. (Courtesy of Capt. Robert Russo.)

This vertical stabilizer and rudder separated from N86511 moments before the plane plunged into Jerry Broz's cornfield, at Sixty-first Street and Bentley Avenue. This accident, as well as another major Chicago air disaster, American Airlines Flight 191, need never have occurred. (Courtesy of William C. Aitken.)

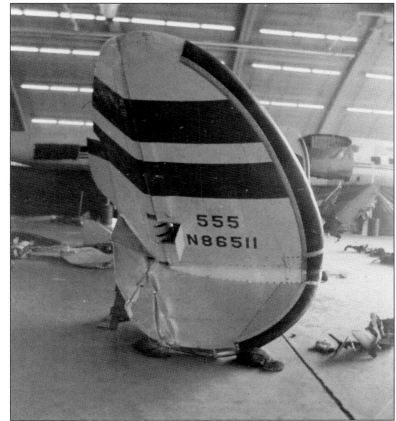

Bill Aitken was TWA's technical liaison to the CAB. The board's conclusions were published in late 1962, more than a year after the crash. This disaster is still discussed by pilots and aviation enthusiasts five decades later. (Courtesy of William C. Aitken.)

BOLT MISSING

TWA mechanic William Aitken holds duplicate of bolt being sought by FBI agents at scene of Constellation crash near Clarendon Hills. CAB probers believe bolt came off in flight causing pilot to lose control. TWA officials believe bolt was sheared off by impact of crash. (UPI)

Midway Airport is seen here nearly deserted in May 1962; only CHA's helicopter remains. The original Chicago Air Park hangar is visible at lower left, just before the s-turn on Cicero Avenue. (Courtesy of Robert F. Soraparu.)

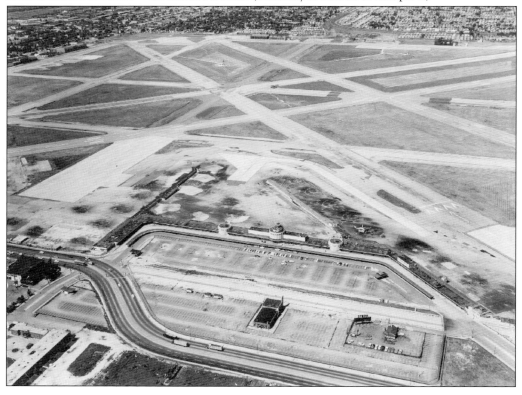

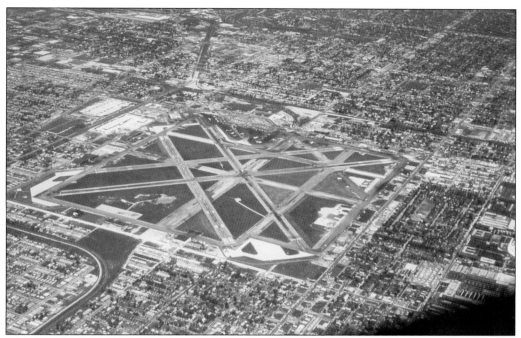

This aerial view was shot just prior to the airlines' mass exodus from Midway in May 1962. (Courtesy of Robert F. Soraparu.)

This United Viscount, or one identical to it, was the last scheduled flight of the majors to depart Midway, on July 9, 1962. (Courtesy of Robert F. Soraparu.)

The majors came back in 1964 with the advent of the Boeing 727 and Douglas DC-9 jets. American 727s became a familiar sight at Midway in the first years of the Jet Age. (Courtesy of Robert Jesko.)

Braniff came back as well, with scheduled 727 flights out of Midway in the mid-1960s. (Courtesy of Robert Jesko.)

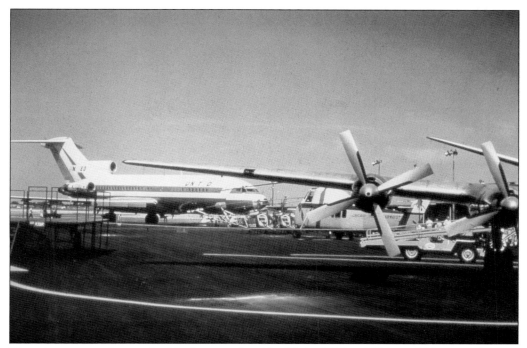

There is no generation gap in this photograph, with a United 727 and Chicago Helicopter Airways S-58 standing by, WGN "trafficopters" parked in the background, and a Vickers Viscount in the foreground. (Courtesy of Robert Jesko.)

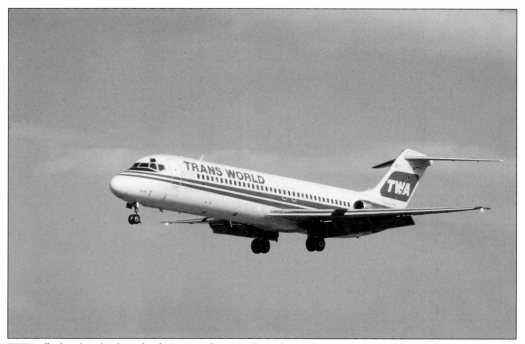

TWA flights by the hundreds, using the new Douglas DC-9, were served by Midway beginning in the mid-1960s. (Courtesy of Robert Jesko.)

The Boeing 737, another medium-hauler jetliner, came along in 1968. This Continental 737 turns base-to-final for the landing at Midway. (Courtesy of Robert Jesko.)

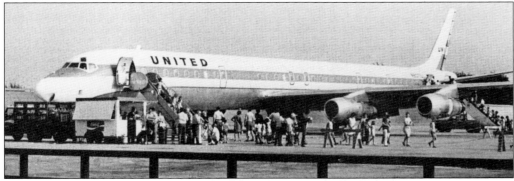

On September 4, 1971, a United DC-8, one of the big jets, landed at Midway. Capt. Elroy "Buck" Hilbert remarked about that flight, "I took a DC-8 into Midway one time for a United Display. That was a challenge . . . for some, but we had no problem. I can only say MDW was a pilot's airport, requiring precision and dedication. It was too scary for some pilots and it did take determination and ability to fly into and out of there." (Courtesy of Robert F. Soraparu.)

Bill Aitken is seen with his colleagues in this TWA newsletter. The airline was justifiably proud of its southwest-side boys for handling so many DC-9 flights out of Midway when TWA was already doing great business at O'Hare. (Courtesy of William C. Aitken.)

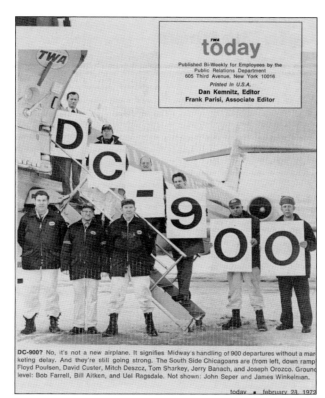

TWA today

Published Bi-Weekly for Employees by the Public Relations Department
605 Third Avenue, New York 10016

Printed in U.S.A.

Dan Kemnitz, Editor
Frank Parisi, Associate Editor

DC-900? No, it's not a new airplane. It signifies Midway's handling of 900 departures without a mar keting delay. And they're still going strong. The South Side Chicagoans are (from left, down ramp) Floyd Poulsen, David Custer, Mitch Deszcz, Tom Sharkey, Jerry Banach, and Joseph Orozco. Ground level: Bob Farrell, Bill Aitken, and Uel Ragsdale. Not shown: John Seper and James Winkelman.

today ■ february 23, 1972

Meanwhile, back at O'Hare in 1966, Bill Aitken, right, and Jack Dusak, left, pose in a promotional shot for an aviation oil sealant ad going into a magazine. On another note, Dusak recalls, "We were surprised at how easy the big jetliners were to maintain." (Courtesy of William C. Aitken.)

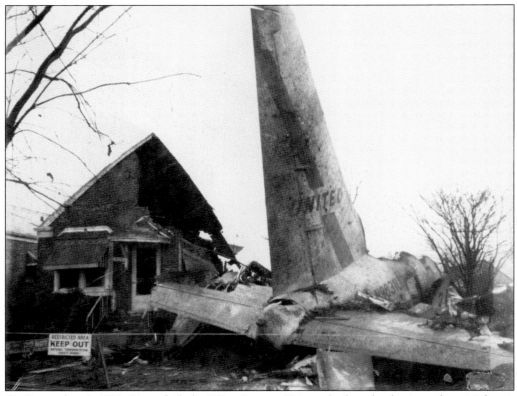

On December 8, 1972, United Flight 553, a Boeing 737, crashed on final approach to Midway's Runway 31L, killing 45 people. Among those killed were Illinois congressman George W. Collins and Dorothy Hunt, the wife of Watergate conspirator E. Howard Hunt. Also onboard were CBS News correspondent Michele Clark and Dr. Alex Krill, a noted University of Chicago ophthalmologist. (From the Midway Historians Collection.)

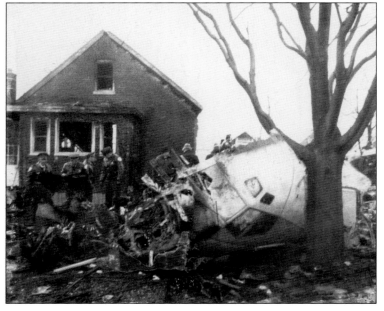

This surreal view shows the port cockpit sheared in half. United captain Wendell Whitehouse, who perished in the wreck, was one of United's most skilled pilots, with a prior background in aviation air shows and precision flying. This flight had a three-person crew, even though the 737 only required a flight crew of two. (From the Midway Historians Collection.)

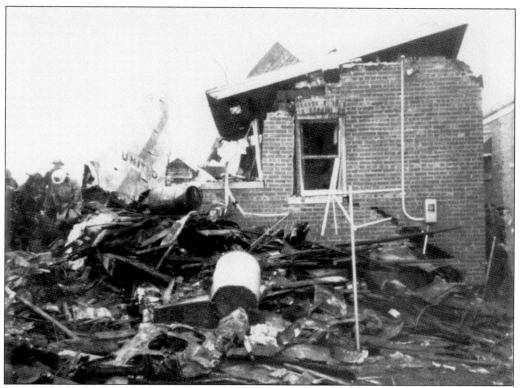

Residents of the neighborhood couldn't wait to see the tail and other remains of the aircraft being lifted aboard trucks and hauled off. (From the Midway Historians Collection.)

The KEDZI Locator Outer Marker (LOM) at Eighty-seventh Street and Kedzie Avenue, 3.3 miles from Midway, is a final approach fix for instrument aircraft inbound to Runways 31. On December 8, 1972, as United Flight 553 approached Midway, KEDZI's signal was heard in the cockpit. However, for reasons unknown, the high-time flight crew was allowing its altitude to deteriorate dangerously. Too late, it attempted to climb out, and too low to recover, the jetliner descended under high power into a quiet neighborhood, destroying homes, killing two residents, and exploding. (Author photograph.)

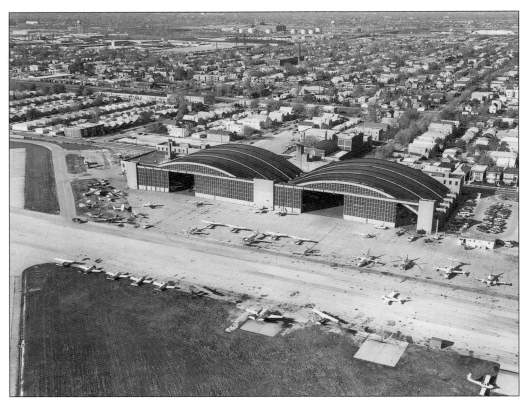

From the early 1960s on, Midway's hangars housed general aviation tenants such as Arnold Zimmerman's Zimtac Aviation; Aviation Professionals, Inc. (API); Gerald R. Hecko's Horizons Unlimited; and the Lawrence family's Chicago Skyline. Aviation Training Enterprises (ATE), a Midway institution since 1947, thrived. Standard Oil and Sears both built corporate aviation centers, Monarch moved into the Delta Airlines hangar, and Esmark moved into the Eastern hangar. T&G Aviation began training, charters, and rentals. Aviation Red Carpet also became a new south ramp resident. (Courtesy of Patrick Bukiri.)

The first product of deregulation to play a key role in Midway's revitalization as a commercial airport was Midway Airlines, which inaugurated service in November 1979. From that time forward, Midway Airport continued growing again, just as it had in the 1930s. In the beginning, Midway flew DC-9-10s, such as N1066T. (Courtesy of Robert Jesko.)

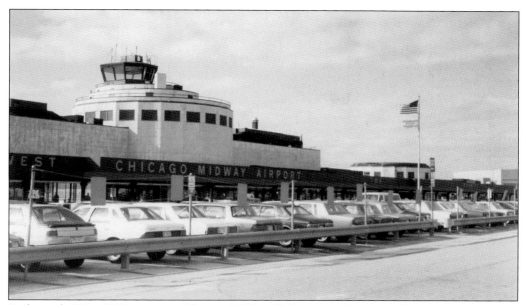

In the mid-1970s, ATE instructor Thomas E. Wartell also trained in air traffic control and worked at Midway tower near the north terminal for a time. He recalled, "That North Terminal was deserted except for Delta, and one security officer. You could've thrown a bowling ball from the south end and it wouldn't have hit anything except that cop." This early-1980s photograph shows that the terminal did not stay deserted. (Courtesy of Fred Hartmann.)

Some airlines never carried passengers. Carriers such as Apollo, Basler, Buckeye, SMB/Stage, and Viking Express operated Beechcraft 18s at night and carried canceled checks, newspapers, and airmail. Aerodyne flew Beech King Airs. United captain Robert Russo remembers nights on the radio as Midway tower cleared one aircraft after another. Buckeye had a regular route to Rockford, Illinois, and Basler came in from Oshkosh, Wisconsin, at 10:00 p.m. every night, leaving only minutes later. Viking flew the *New York Times* to Minneapolis every night, and Aerodyne carried canceled checks for the Federal Reserve Bank. (Courtesy of Patrick Bukiri.)

This view on short final for Runway 22R at Midway Airport is extremely familiar to pilots of all ages and eras, but it is always satisfying. (Author photograph.)

American Trans Air (ATA), another post-deregulation startup, operated Boeing 757s such as N517AT to and from Midway from the late 1980s until 2008, when Southwest Airlines purchased all assets of ATA Airlines. This beautiful jetliner was one of the largest types operating regularly from Midway. (Courtesy of Robert Jesko.)

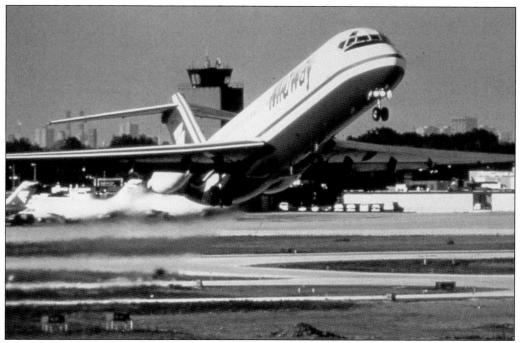

Always thrilling to watch, a Midway jet climbs like a homesick angel off the square-mile airport in the 1980s. (Courtesy of Robert F. Soraparu.)

In June 1992, these incoming "bogies" signaled a moving and amazing event at Midway: the 50th anniversary of the Battle of Midway, from which the airport derives its name. Military and vintage aircraft of all types arrived and performed, and for one day, Midway was transformed once again into a military airfield. (Courtesy of Robert Jesko.)

This sortie on the south ramp consisted of two AT-6G Texans, one with Bob Jesko called *Mr. Bill*, plus a Beechcraft T-34 Mentor, at the 50th anniversary of the Battle of Midway in 1992. (Courtesy of Robert Jesko.)

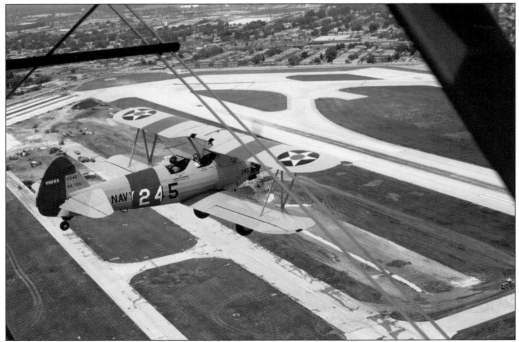

Braniff's Bob Jesko, who took this photograph from a Boeing PT-17 Stearman, flies in formation with another Stearman over Midway's northwest corner, Fifty-fifth Street and Central Avenue. (Courtesy of Robert Jesko.)

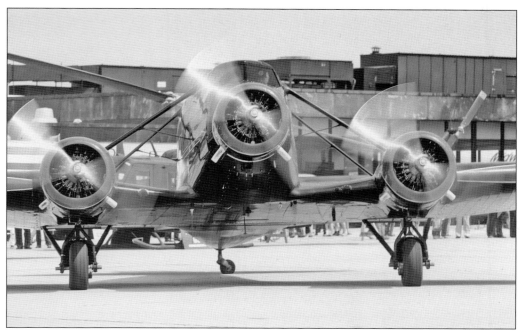

Retired American Airlines captain Eugene Coppock's fully restored 1934 Stinson Model A trimotor, in American Airlines livery, brought back the golden age of aviation and the early days of Muni during the 1992 celebration. (Courtesy of Robert Jesko.)

Air National Guard choppers park on the south ramp at the Illinois Air National Guard hangar; built around 1940, it is the oldest existing aircraft hangar on Midway Airport. (Courtesy of Robert Jesko.)

After Matty Laird moved from Ashburn, his former aircraft factory became the Muni home of Howard Aircraft in 1937. The building is located at 5201 West Sixty-fifth Street, exactly two blocks south of Midway. (Courtesy of John and Robert Dusak.)

On December 8, 2005, this Southwest Airlines Boeing 737 came in to land on Runway 31C (formerly 31L) during a heavy snowstorm and ran off the runway at the far end, taking out a fire hydrant and hitting a vehicle in the intersection of Central Avenue and Fifty-fifth Street. The collision killed a six-year-old boy in the back seat and began impassioned discussions about aviation safety and Midway's runway lengths. Runway-overrun safety measures were subsequently implemented. (Author photograph.)

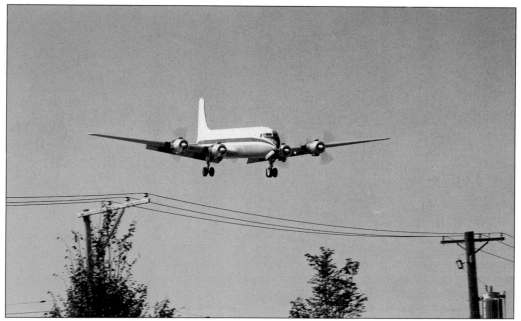

On October 4, 2011, Florida Midway Historian Fred Hartmann notified club chief and UAL captain Robert Russo of an incoming flight: Florida Air Transport's 96-passenger Douglas DC-6, N108BF, *Clipper Liberty Bell*, was flying into Midway. Russo notified fellow Midway Historian Bob Jesko, who captured the magical event on camera. (Courtesy of Robert Jesko.)

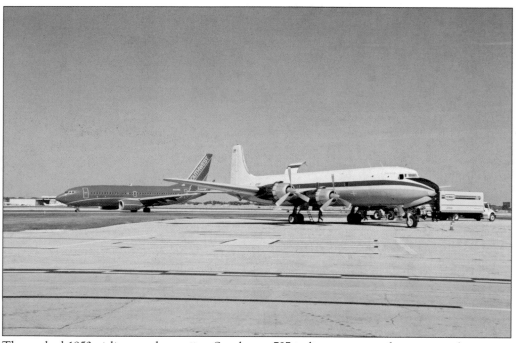

The parked 1953 airliner and a taxiing Southwest 737 jetliner meet on the ramp as if in a time warp. (Courtesy of Robert Jesko.)

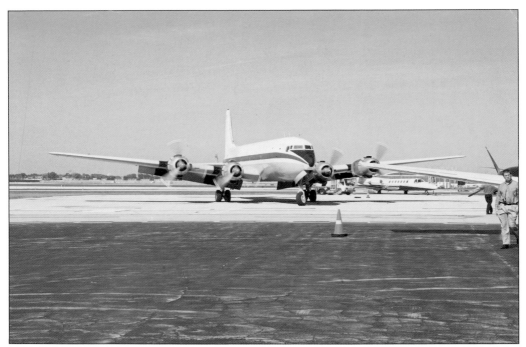

The pristine DC-6 taxies out for run-up and takeoff. That day, Bob Jesko once again heard the Midway symphony, that amazing grumbling and roaring of four huge radials combined with the sound of harmonized constant-speed propellers going supersonic. (Courtesy of Robert Jesko.)

Over Sixty-third Street and Central Avenue, a Southwest Airlines 737 flies short final for Runway 4R. Southwest may be headquartered in Dallas, but Chicago knows that Midway is the airline's home away from home. (Courtesy of Robert Jesko.)

DISCOVER THOUSANDS OF LOCAL HISTORY BOOKS
FEATURING MILLIONS OF VINTAGE IMAGES

Arcadia Publishing, the leading local history publisher in the United States, is committed to making history accessible and meaningful through publishing books that celebrate and preserve the heritage of America's people and places.

Find more books like this at
www.arcadiapublishing.com

Search for your hometown history, your old stomping grounds, and even your favorite sports team.

ABOUT THE MIDWAY HISTORIANS

The Midway Historians is a group of pilots, mechanics, historians, authors, and aviation enthusiasts whose purpose is to preserve the history of Chicago Midway International Airport and Chicago's aviation legacy.

Founded in April 2004 by David Kent, Christopher Lynch, and a core group of dedicated individuals who love the "World's Greatest Airport," the Midway Historians bring back the excitement, stories, photographs, sounds, and nostalgia of Midway during the golden age of aviation and the Air Age. From our ranks come five authors, with more soon to join.

The group meets three to four times per year in Willowbrook, Illinois, and maintains an online presence as well. Inquiries regarding membership and other resources are welcome, regardless of location. There is no cost for membership.

The group plans Midway and Chicago-area aviation events as well. For more information, please visit www.midwayhistorians.com or contact the Midway Historians at info@midwayhistorians.com.